CW00540384

SECRET DERBY

Maxwell Craven

AMBERLEY

Acknowledgements

Many people have helped me with this book although, because it draws heavily on my detailed history of the town and the people who made it famous, the majority of them are acknowledged in these *urtexts*. Nevertheless, I am particularly grateful to Tony Butler, executive director of Derby Museums Trust (DMT), and Jonathan Wallis, head of collections there. Thanks to Joy Hales, editor of *Derbyshire Life* and Derby's plushly rehoused Local Studies Library and the helpful people who work there so cheerfully. Thanks also to James Darwin, Emeritus Professor Jonathan Powers, my colleagues James Lewis and Stephen Iredale at Bamfords Auctions, and above all, my wife, who has provided much needed advice and help and who has, thanks to uniformly dull weather this year, at short notice, driven me out to various recondite portions of the city to take much needed photographs illuminated, as they must, by sunshine and blue skies.

First published 2016

Amberley Publishing
The Hill, Stroud
Gloucestershire, GL5 4EP

www.amberley-books.com

Copyright © Maxwell Craven, 2016

All the illustrations are the authors, except where acknowledged.

The right of Maxwell Craven to be identified as the Author of this work has been asserted in accordance with the Copyrights, Designs and Patents Act 1988.

ISBN 978 1 4456 5369 3 (print)
ISBN 978 1 4456 5370 9 (ebook)

All rights reserved. No part of this book may be reprinted or reproduced or utilised in any form or by any electronic, mechanical or other means, now known or hereafter invented, including photocopying and recording, or in any information storage or retrieval system, without the permission in writing from the Publishers.

British Library Cataloguing in Publication Data.
A catalogue record for this book is available from the British Library.

Origination by Amberley Publishing.
Printed in Great Britain.

Contents

Introduction

The *Oxford English Dictionary*, that reliable standby, defines a 'secret', *inter alia*, as 'a thing known only to a few, a mystery', and it is the things known only to a few and the mysteries that Derby hides which I have tried to lay bare for visitor and local resident alike. This provides much latitude, of course. To the discerning visitor, a new place will harbour numerous enigmas which, upon closer acquaintance, will become less so. To the reasonably well-informed inhabitant of the city, the Derbeian, there will still be things that seem obscure about the history and topography of the settlement. Thus it has been possible to perhaps suggest that in the pages that follow some attempt has been made to unravel the not-so-obvious (secrets, as far as the outsider is concerned) as well as to delve into the more obscure aspects of the city.

Not that there is any intention to confine this unravelling just to historical obscurities, but to illustrate those aspects upon which it is felt worth throwing a little light by taking the reader to places that will help to make the point or at least act as *foci* of the unravellings.

Derby has had, after all, some 2,000 years of history, so there are plenty of obscurities, misunderstood sequences of events and unjustly neglected aspects – things known only to a few. Although there was without doubt settlement in the area of Derby from at least the Bronze Age, attested by archaeology and chance finds, we cannot piece together a narrative history prior to the Roman invasion. Within a generation of the conquest by A. Plautius in AD 44, a small military fort had been established astride Belper Road, on rising ground immediately north of Derby, beside an ancient trackway that ran south to north up the long ridge upon which Derby was later built. Yet that fort was but a temporary measure and a large one was founded on a more permanent basis across the Derwent from AD 80–90, probably as part of the enlargement of the province under Governor Cn. Julius Agricola. This in its turn swiftly became a small Roman town and by the end of the third century had been walled about before falling into desuetude in the years following the collapse of Roman rule early in the fifth century.

That might have been it, for there followed a 200-year knowledge blackout. It was not until the new Saxon kingdom of Mercia had finally adopted Christianity in the late seventh century that anything happened, although archaeology suggests that the Roman town probably continued as a small settlement; it certainly existed at *Parva Ceastre* or, in modern parlance, Little Chester, in the eleventh century.

The first thing to appear on the site of central Derby itself was a Saxon minster church and its small enclave for missionary priests and associated helpers, but there was no town as such until King Alfred's doughty daughter Æthelflæda of Mercia had ejected the Vikings from the area in 917. Within a decade, a fortified settlement called a *burh* had

been established, and by the time Domesday Book was prepared in 1086, a distinct town was flourishing.

Thereafter, Derby never really looked back. It became a county town until 1952, was much admired by Georgian visitors who praised its handsome streets, and until the Industrial Revolution, specialised in the crafting of luxury goods to meet the requirements of the gentry inhabiting Derby's unusually rich hinterland. Fine clocks, wrought iron, superb china, silk – all began to be made in Derby from the reign of George I.

Yet the Industrial Revolution was something to which Derby punched well above its weight. It was home to two members of the Lunar Society – John Whitehurst FRS and Erasmus Darwin FRS – that coterie of natural philosophers and gifted entrepreneurs which drove the Midlands Enlightenment. They also attracted around them men of talent such as Derby's internationally renowned painter Joseph Wright ARA and men of commercial enterprise such as Jedediah Strutt and Sir Richard Arkwright, among others. Their presence raised standards and advanced the industrialisation of Derby and, by 1800, there was cotton spinning, copper milling and iron founding flourishing in the town.

This led to a vast increase in population and pressure on an antiquated infrastructure with which the old chartered town council could not keep pace. A succession of Improvement Commissions between 1768 and 1825 radically improved infrastructure and the coming of the railways in 1839 was the final element that projected Derby into the industrial age.

In the late twentieth century, by contrast, the heavy industry has largely been superseded by new, high-tech industries, but leaving behind, ironically, those luxury industries that had so marked Derby out before the Industrial Revolution: a clockmakers in Smith of Derby and Royal Crown Derby to name but two. Rolls-Royce began as a luxury industry too, being a latecomer foundry set up to produce luxury cars, yet the demands of two world wars drove that aspect of this still-flourishing company out of the town in 1939, never to return, although the former site of Derby's Municipal Aerodrome is now host to Messrs Toyota.

In 1927 Derbyshire became a Church of England diocese with its cathedral in Derby, at All Saints' Church, and exactly fifty years later, Derby became a city. It is still bursting at the seams today and, despite being run for decades by a succession of legislators with little understanding or heed for its historic fabric, is still a handsome town with much of interest and a fair sprinkling of secrets to be discovered.

1. Beginning Secrets

To get a flavour of the way Derby grew up, one has to try and imagine the topography of the place before it got covered with buildings. Originally, it sat on a ridge running north from what is now the junction of Albert Street and Victoria Street. Immediately to the east is the Derwent, flowing roughly north but meandering slightly south to south-east as it passes through Derby itself. The Derwent – its name, as with so many English rivers, is of British (old Celtic) derivation from *deru* meaning oak and *wen* meaning white/pale, thus 'place/river of the white oaks' – forms a sort of axis for the town.

Ancient Roads

Sometime in the ages preceding recorded history, a second axis came into being, this time man-made. A trackway was formed from a crossing of the Trent at Swarkestone running approximately northwards to Derby. It came down to the Markeaton Brook, which now flows beneath Victoria and Albert Streets (formed in 1839 and 1848, respectively), crossed what was then marshy ground either side of it, and ascended the ridge keeping just below its highest point following the course of the Derwent to Duffield and thence to points north across the Iron Age territory of the tribe called the Corieltauvi, which has left behind little but coins.

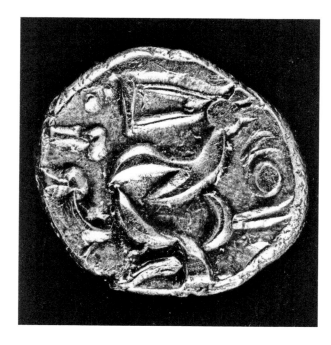

Corieltauvian gold stater found on Long Lane, 9 miles west of Derby 1950s. (DMT)

How do we know? Well, looking at a map of any age its course is plain to see, but it was only by looking at records of prehistoric and Roman find-spots in the Derby area that it became clear that Iron Age man, if not his Bronze Age predecessors, had lost quite a bit of stuff as they passed along its course between Swarkestone and Duffield. This is especially true of Swarkestone, for the famous bridge there – an elegant stone bridge of 1797, designed by County Surveyor Thomas Sykes – connected on its south side to a long causeway, pierced by arched apertures designed to cope with occasional flooding. Conventional wisdom will tell you that it is a medieval bridge and, indeed, some of the flood relief arches under the causeway are of medieval date, even to being pointed.

However, the big secret here is that the 'bridge' was probably a 1,000 years old in medieval times. Over the last fifty years, a great number of Roman finds have been recorded either side of the causeway and the road leading up to the bridge on both banks, clearly indicating its much earlier origins.

If you think about it, this makes perfect sense. The Roman roads of the area run south-west to north-east – essentially Rykneild Street as this important artery was later called – and another runs from Derby due west to *Deva* (Chester) via Chesterton (Staffs.), near Newcastle-under-Lyme and Rocester. Yet supposedly, if you wanted to reach *Londinium*, the provincial capital, you would have had to head east across what is now Derby Racecourse playing fields, then veer south-east along the old Nottingham Road until you reach Willoughby-on-the-Wolds from whence you can access the Lincoln to Leicester Road and thence south. This seems a ludicrously long way round. In fact, by moving down Derby's prehistoric spinal trackway to Swarkestone Bridge – probably a brushwood-based causeway, like those found on the Somerset levels near Glastonbury thirty years ago, with a ferry or timber bridge across the main river channel – you could access *Ratae Corieltauvorum* (Leicester) directly. It makes perfect sense, especially when one remembers that *Derventio* and *Ratae* were both in the same tribal area or *territorium* as Iron Age Corieltauvi tribe.

Thus, running approximately north–south through the site of Derby, one has two axes: the river and the ancient trackway. Furthermore, the Romans discovered that the then lowest safe bridging point of the Derwent was 1 mile north of the present city centre, just by the small military fort they built immediately west in the AD 60s as the tide of conquest moved inexorably north. It was at this point that they built a bridge and in the AD 80s established their small town, *Derventio*, named after the river upon which it stood on the east bank.

Roman Derby

Although there is really nothing Roman above ground in the delightful suburb of Little Chester, partly on the site of *Derventio*, it is there one has to go to get a feel for the size and layout of the place. The other place to see, to follow such a visit up, is Derby's excellent main museum in the Strand, where the most interesting of the items recovered from the site over the years, including a jaunty-looking (and perfectly naked) local version of Apollo set in a little gabled niche can be found on display.

At Little Chester itself, all that remains on the ground is the street pattern. The layout of streets is almost always a good indicator of the age of a settlement, however altered

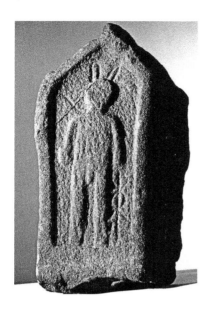

Stone bas-relief carving of a deity believed to be a local interpretation of the Roman god Apollo, found at Little Chester and now in Derby Museum. (DMT)

by developers' apartment blocks, students' residences and office complexes. At Little Chester, the original fort is largely built over by late nineteenth-century (and perfectly pleasing) artisans' cottages for the workers of Sir Alfred Haslam's local foundry. Yet it had an east–west road (the *decumanus*) and a north–south one (*cardo*) as well forming a sort of framework for the rest of the layout within the earthen ramparts. Thus, turning left off the Mansfield Road by the Edwardian Coach & Horses pub, runs Old Chester Road, once the *decumanus* of the fort and later small town of *Derventio*. If, by the Coach & Horses, one turns east, Vivian Street appears as the extension of the *decumanus* eastwards and seems to lie on the old Roman road which ran in that direction. It lost its status as a route when the railway came in 1840 and the Mansfield Road had to be skewed to a bridge over the line.

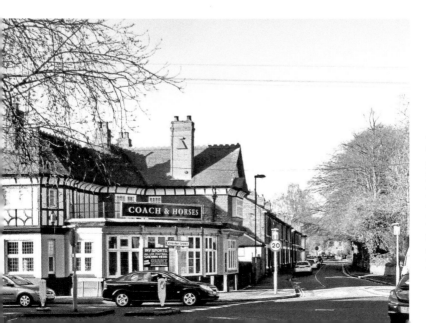

A view west down Old Chester Road (the former *decumanus* of Roman *Derventio*) from Mansfield Road, with the Coach & Horses (an Edwardian replacement of Stukeley's Crown alehouse) on the left, February 2016.

DID YOU KNOW...?

Beneath Parker's Piece, Little Chester's riverside park, there lies an extensive Roman baths complex, excavated in 1926.

Walk down Old Chester Road, and one passes the lost site of Little Chester Manor, now built over with Derventio Close. This charming early seventeenth-century brick house (carelessly demolished for a motor garage in 1964) had a much earlier plinth, and archaeological investigation of its site in the 1990s revealed that this had been built directly onto the footings of a Roman building of some status, clearly implying some kind of continuity.

Beyond, the road ends at the riverbank, shortly to be buttressed off by a highly intrusive Environment Agency-imposed 'once-in-a-century' flood prevention works. Either side stand two earlier houses, both once prebendal farms, now comfortable private homes. That to the north, with blind brick arcading, is Derwent House, said to have had a Roman cellar, although we cannot check this because in the 1970s, when owned by the city council, this vital void was shot full of cement 'to prevent damp'. That to the south, Stone House Prebend, has medieval origins and a fair amount of original ashlared stonework survives.

Below: Derwent House, with the east front seen from the carriage arch of the former stable block by the present car park, February 2016.

Right: Where Old Chester Road reaches the river: the site of the former west gate of *Dervenio*, soon to be wrecked by a thoroughly intrusive (and probably unnecessary) flood prevention scheme.

Stone House Prebend: eighteenth-century south front from the river, July 2014.

Before one reaches these two gems, there is a turning to the south – City Road. This was once the *cardo* of *Derventio*, later becoming the normal route from the successor village to Derby. Its course northwards had been obscured by vast quantities of tarmac put in by the council to serve the amenities of a car park and tennis courts. In a housing complex just off Marcus Street, there is preserved the top of a Roman well, and much of the stone walling surrounding the two prebendal farms is reused Roman stonework.

Left: A view south down City Road (the former *cardo* of Roman *Derventio*) from Old Chester Road, February 2016. The high wall to the right is the mid-nineteenth-century factory of Alderman Sir Alfred Haslam's Union Foundry, forty-four bays long.

Right: The preserved Roman well behind the housing association flats in Marcus Street, February 2016.

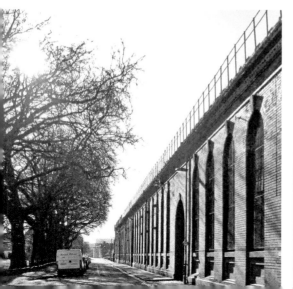

In 1721, the antiquary William Stukeley drew a map of Little Chester showing the street pattern and also the town walls. They were discovered by excavation in 1963 to be 9 feet wide at the base, were built into the original earthen bank or berm of the first-century fort and could be deduced as being something like 20 feet tall, roughly agreeing with Stukeley's description. In his day, they were beginning to be demolished, not for building stone but ground up to make lime. This also tells us that they were not made of local millstone grit sandstone but of carboniferous limestone from the white peak, although why this should be is not clear. Lead ore was also coming down from there too, for it was being processed on a site just north of Little Chester's wall and sent on as rectangular lead 'pigs' by river.

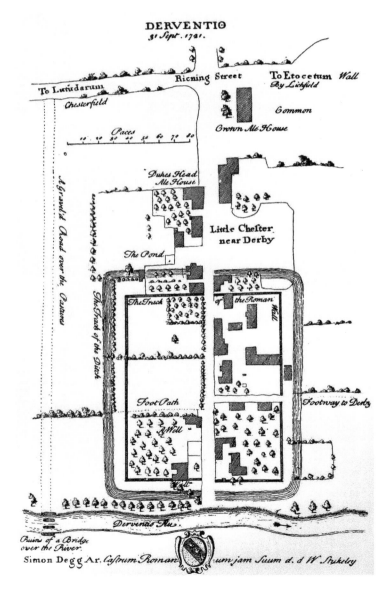

Little Chester: Stukeley's Map. Just to cause confusion, east is at the top.

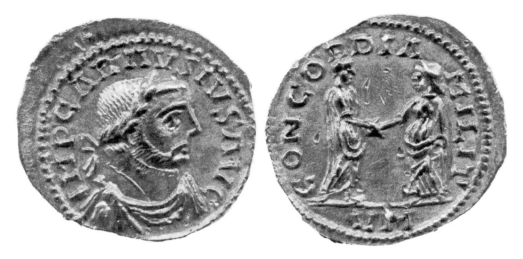

Gold *aureus,* struck at the Rouen mint of the breakaway Roman emperor Carausius, found near Derby and now in Derby Museum The obverse legend reads '*Imp[erator] Carausius Aug[ustus]*' and that on the reverse, '*Concordia Milit[es]*' (the support of the soldiers). (DMT)

Stukeley also recorded that the river was crossed by a bridge, traces of which could be found in the river, also immediately north of the settlement. The Alfreton sub-aqua club managed to identify some of the pier bases in the stream's bed in the early 1990s before a council-sponsored outbreak of health and safety curtailed operations. More were discovered at a site beyond the large tract of green south of the Stone House Prebend, indicating two crossings. There having been no reports of arch stones and other solid structures, it is assumed that both bridges were of timber supported on stone cutwaters.

The size of the fort at *Derventio* is thought to have been sufficient for something like 500 men – a cohort in Roman terms – but in the later second century, the unit was probably auxiliary (non-Roman) troops rather than a detachment of a legion. After the emperor Septimius Severus died at York in 211 while waging a campaign against the northern tribes, it is thought that the troops that might have been at *Derventio* had been set north, did not return and were posted to some other part of Britain where they were most needed. From then on, the settlement became a thriving small town, fuelled by pottery making, lead smelting and other minor industries. Indeed, the citizens were sufficiently wealthy to have built plinth and other high-status tombs along the road out of the town to the east, excavated in 1976.

It was during the period of chaos that afflicted the empire in the late third century that the walls William Stukeley recorded were built, probably under the breakaway emperor Carausius, a superb gold coin of whom can be seen at the museum, found locally. Not only did they enclose the core of the settlement, roughly co-terminous with the by now secularised military fort, but were penetrated by four gates and punctuated by round bastions from which defenders could enfilade attackers with missiles, whether bolts or stones, fired by trebuchet.

Roman Eclipse

The East Gate of *Derventio* was around halfway down Old Chester Road and outside it was a building of unknown purpose, into the decaying floor of which were buried seventeen armed Saxon men and six women, buried early in the seventh century. Some of the men had suffered head traumas, although not all appear to be the victims of violence. It was their shield bosses and spear heads which identified them as Saxons, although being buried, as Roman custom had long insisted, outside the walls of the town, one wonders if this too represented continuity. Had they been invited to settle there by the Romano-British population or were they among the early Mercians expanding into what had been unchronicled British territory for 200 years?

Modern scholarship today considers the joint victory of the British king Cadwallon and the emergent Mercian prince Penda over the Northumbrians as trigger for the gradual takeover of the former territory of the *Corieltauvi* (which seems to have survived as an administrative unit) by the Saxons and their joint defeat by the same Northumbrians on the Winwaed (probably the Went, in Yorkshire) in 654 as the end of British power east of the Dove. Thereafter, it continued to shrink until around 685 when Mercia appears, fully formed.

The transition was no doubt lengthy and challenging for the British population, who were at least nominally Christian from the fourth century. That Christianity survived in the immediate vicinity of Derby in the Dark Ages is not in doubt. Topography tells us that there was probably a pre-Saxon church in or near Wirksworth (mooted by some scholars as the otherwise unlocated lead capital of Roman Britain, *Lutudarum*), if only because it lies on the Ecclesbourne, where *eccles* derives, as does modern Welsh *eglwys*, from the Latin *ecclesia* meaning church. There are other *eccles* place names surviving in Derbyshire too – at Stanton in Peak and Tideswell among others. The persistence of the cult of St Helen, mother of the emperor Constantine and finder of the True Cross in the area, notably at Derby, is also often taken as evidence for this survival.

We do not know what political unit held sway over the Derby area in these clouded years, but as eastern Mercia was approximately co-terminous with the Romano-British *territorium* of the *Corieltauvi*, then it may have survived as an independent Celtic kingdom, like the fractionally better chronicled Elmet and *Loidis* (Leeds) in Yorkshire and *Luitcoed* (Lichfield) to the west, all of which survived into the 630s.

Yet whatever the fate of *Derventio* between the early to mid-fifth century (when some very worn Roman coins of the late reign of the emperor Theodosius I (thus 390s) were discarded there as worthless) and the ascendancy of King Penda from 642, it effectively concluded the opening chapter of Derby's history, leaving the nascent settlement of Little Chester to be absorbed into Derby 1,300 years later.

2. Refoundation Secrets

What We Learn from a Battle

The *Anglo-Saxon Chronicle*, under the year 917, has a dramatic and intriguing entry:

> With the help of God, before Lammas, was obtained the borough which is called Derby
> with all that belongs to it, and there also four of her thegns who were dear to her were
> killed within the gates.

This raises a number of questions. In 917, Queen Æthelflæda of Mercia (usually called
the 'Lady of the Mercians') was fighting hard to roll back the Vikings who had overrun
eastern Mercia in 874. She came with an impeccable pedigree for such activities, being the
daughter of King Alfred, who had dramatically done the same for Wessex in conjunction,
as a recently discovered coin has demonstrated, with Mercian king Coelwulf II, previously
stigmatised as a Viking puppet ruler. That she was leading the fighting and not some
male Mercian leader is that her husband, Æthelræd, who had initiated the campaign, with
the support of his wife's brother Edward, had died in 910 leaving her a widow with a
daughter and sole heiress of some nine years of age. Yet instead of losing momentum, his
warlike widow had assumed control and, with immense flair and bravura, had carried the
campaign on to its successful conclusion in 918.

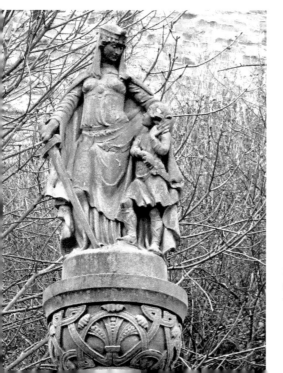

Statue of Queen Æthelflæda at Tamworth, her main
strongpoint during her campaigning and the *burh* in
which she died in 918.

There are however some secrets in the *Anglo-Saxon Chronicle* extract. Derby did not then exist, and in any case had no walls and gates. To solve this conundrum, we need to regress 300 years.

The kingdom of Mercia was a recent construct then; we do not hear of it in any significant way before the King Penda's career of conquest (mainly of Northumbria, but also of the west midlands) which Bede tells us was a twenty-year one, thus starting in around 635 but which other evidence informs us had certainly begun by 642. The former territory of the *Corieltauvi* appears to have fallen under his sway at this time.

Penda was a pagan, despite his habit of allying himself with the British king Cadwallon (a Christian) but, on his death at the hands of King Oswiu of Northumbria in 654, the latter took control of Mercia until ejected by Penda's younger son, Wulfhere, in 658. Wulfhere had accepted Christianity, receiving a Northumbrian mission led by St Chad to evangelise his Anglian subjects. Chad settled at the decaying former Roman settlement of *Letocetum* (Wall, Staffs) conquered two or three decades before, and refounded the settlement a mile and a half to the north, at Lichfield. One of Chad's earliest pupils was King Wulfhere's daughter, Werburgh. She was an enthusiastic convert and later became Abbess of Ely, reforming convent life for women, working miracles and dying in 699, being rapidly canonised. A church in a tiny settlement called *Waldewic* by the Markeaton Brook on the western part of modern Derby was soon afterwards dedicated to her.

The need to evangelise the Anglian settlers of Mercia led, around 700 or not long afterwards, to the foundation of a church on the future site of Derby to act as a base for the priests who were to return the word of God to the countryside. Such churches were called minsters.

To accommodate the houses of the six canons (missionary priests) and those who supported them, a small settlement grew up closely around the church, outside of which a great stone preaching cross was raised. The ancient trackway that ran up the ridge on which it was built was diverted around this settlement to its west, before resuming its original course. Beyond that, no developments on the future site of the city took place.

Early (pagan) Anglo-Saxon cremation urn found on the site of Willington power station, early 1950s. (Late Roy Hughes)

Less than 800 yards to the north though, a small settlement grew up (or survived) within the Roman walls of *Derventio* called *Parva Caestra* or Little Chester.

Christianity Returns

The name of the settlement around the mission church is not known, but it would not have been Derby, as that has a Norse 'by' meaning 'place' ending and the Norse had yet to appear. As the Roman fort became Little Chester, the new enclave may have kept an Anglianised version of the old Roman name of *Derventio*. A later chronicle calls Saxon Derby 'Northworth[y]', but recent scholarship inclines to the belief that the name referred to the whole of the country north of the Trent (and of Repton, the old 'capital' of Mercia), east of the Dove and west of the Erewash, the minster church on the site of Derby being its spiritual focus.

Like the British settlement pattern that preceded it, the Northworthy area was populated with settlements but lacked a nucleus, and it was into this rather unstructured polity that the Viking Great Army irrupted in the winter of 874–75, deposing the Mercian King Burgred (allowing in Coelwulf II to rule the unconquered portions) and passing the winter in camp at Repton. In Derby they appear to have desecrated the minster church, by now dedicated to the Northumbrian martyr-prince St Alkmund, whose relics had been deposited there, and they appear to have refortified the Roman walls of *Derventio*, by now the small village of Little Chester, to make it a crucial strongpoint on the Derwent crossing.

A Battling Queen

Thus, when Æthelflæda, recognised with her late husband in Mercian documents as king and queen, but in later (Wessex influenced) sources merely as an ealdorman (noble) and his wife, came to drive the Vikings out of the area, the secret was that it was at Little Chester they had to besiege the Vikings in their newly refortified stronghold. We can confirm this, for archaeology clearly tells us that the Roman bastions on the walls had been extensively rebuilt by the Vikings, for their pottery and a bone comb were found underneath two of them. After all, as we have seen, there was at this time no Derby, nor any walls around it; the queen's four thegns were killed in desperate conflict within the repaired gates of the old Roman small town.

Yet despite this, Derby still had not been called into existence. The use of the name in the account of Æthelflæda's battle was retrospective, of course. There was to be another drastic change in fortune before that happened.

On 12 June 918, not long after having retaken Mercia, Æthelfflæda unexpectedly died – we presume of natural causes, although subsequent events might arouse one's suspicions. Her only child, the teenaged daughter Aelfwyne, was declared Queen of Mercia. This was obviously too much for her uncle Edward the Elder, King of Wessex, who had supported his sister's campaigns against the Vikings, and six months later, Aelfwyne was spirited away to a convent and never heard of again.

Edward thereupon had himself proclaimed King of Mercia and of all England.

Derby Founded at Last

Although totally ruthless and hostile from a Mercian point of view, it was clearly a good move strategically, for unity against the Vikings represented strength. Edward now

decided to consolidate his hold over Mercia by establishing strongpoints combining a trading element with defence, called *burhs*. He established others in the area too, including Nottingham. Yet in 939 the Viking King of York, Olaf, managed partially to reconquer the East Midlands. It was not until 942 that King Edmund finally retook the area. The Confederacy of the Five Boroughs was instituted over the next twenty years to stabilise the region and create a strong buffer zone against the North. As Dr David Roffe has stated,

> It is clear from the legal principles that it embodied, notably the maintenance of the peace by the community rather than the kin [noble family groupings], that it [the Five Boroughs] was an English innovation of the late tenth century. Yet the secret is that most history books still attribute the Five Boroughs to the Vikings.

This, then, was the newly founded role of the Saxon *burh* of Derby – as a key strongpoint against future Viking attacks. Foundation probably occurred in the mid-920s and the name is a combination not of Norse *djur* meaning 'deer' as earlier accounts suggest, but a hybrid of the first element, *der* of *Derventio* meaning 'River Derwent', plus the Norse suffix 'by'. And while some Saxon *burhs* were walled round (or at least banked), the new Derby was not. It was defended by the Derwent to the east, the marshy Markeaton Brook to the south and west and by a ditch, called the town ditch, across the ridge to the north from brook to river. Although for many years only postulated, the town ditch was finally revealed by archaeology in 2003.

The old minster church of St Alkmund was repaired and beautified. Its interior, including the saint's shrine, much frequented by Northumbrians over the following 600 years (until desecrated in the Reformation) was restored, and the superb Saxo-Norse carved stone sarcophagus was recovered when the church was destroyed for the Derby Inner Ring Road in 1967. It is richly embellished with the interlace decoration of the period. It is now to be seen in Derby Museum, but the secret is that it is clearly not the shrine of the saint.

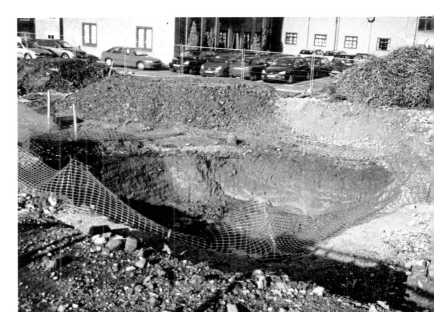

The town ditch revealed by archaeology, near St Helen's Street, March 2007.

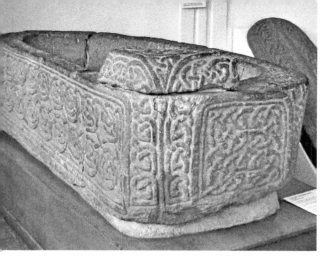

The sarcophagus of Ealdorman Aethelwulf in Derby Museum. Note the fragment of a close-fitting lid on the angle nearest the camera. Beyond, part of a later Viking grave cover from the church can be seen.

As the small surviving scrap of the close-fitting lid establishes, the whole thing was sealed tight, whereas we know that pilgrims could put their hands into the saint's shrine and touch his relics. Sad to say, Reformation zealots destroyed the saint's shrine and tossed it, along with his remains, into the Derwent. The splendid object in the museum is instead the tomb of the Ealdorman Aethelwulf of Northworthy, killed in action against the Vikings in 871 and buried in the church.

A second minster church was also founded, built after Edward the Elder took over, this time to re-evangelise the Viking settlers in the town and district. It was dedicated to All Saints and was at the south end of the *burh,* supported by six canons and a dean. This was amalgamated with the dispersed college of canons from St Alkmund's as a single body and survived until 1549, although the church itself, much rebuilt, is now Derby Cathedral.

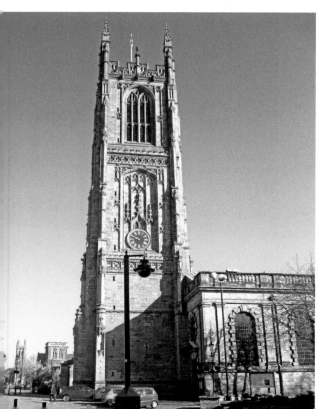

The new, early tenth-century Saxon minster church of All Saints', now Derby Cathedral, seen from Iron Gate, part of the town's ancient spinal road, March 2012. The tower was completed in 1532. In the distance is St Michael and the Catholic church of St Mary.

Somewhere in the vicinity of the cathedral, a mint was also established, from which silver pennies (and some halfpennies) were minted continuously until 1154. The moneyers' names on these coins give us the earliest names of any Derby citizens on record. Around half of them are Norse names, telling us that the new *burh* was in a sense multicultural, combining both Saxons and descendants of their former antagonists, the Vikings.

What There Is to See

Today you can see something of this Saxon *burh*, for between the two churches a grid of streets was laid out. Too see this, one needs to walk to Derby's superb Georgian Cathedral of All Saints. It was designed by Scots architect James Gibbs in a Doric order, not to upstage its striking early sixteenth-century perpendicular tower, built in 1723–25. An ancient street runs either side of it from Queen Street (part of the ancient trackway and now the spinal road of Derby) towards the river, terminating in Full Street, which runs parallel to Queen Street and connects to the latter via a right angle, once called Alderman Hill – yet another west to east element of the grid.

These streets flanking the cathedral (as it has been since 1927) are Amen Alley on the south side and College Place on the north. The large stuccoed building on the north side of the latter is The College, a Tudor brick house of some pretension built on the site of the medieval dwelling of the six canons of the College of All Saints, and subsequently rebuilt in the 1750s and then again in the 1820s, now offices. It is thought that the seventeenth-century pub a few doors down on Queen Street, the Dolphin, once pertained to the college in pre-Reformation days; it claims to have been founded in 1530 and its name is replete with medieval Christian symbolism.

Left: Part of the grid of streets of the Saxon *burh*: Amen Alley, south of the cathedral, looking east to Full Street, February 2014.

Right: Part of the grid of streets of the Saxon *burh*: College Place, immediately north of the cathedral (right) looking east to Full Street, February 2014.

 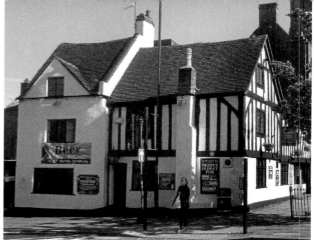

Left: Full Street, the east front of The College, where, until 1549, the canons of All Saints and St Alkmund lived, March 2014. This side was rebuilt *c*. 1813, the part behind in the mid-eighteenth century, but the side facing the Dolphin yard to the north is mainly of Tudor-era bricks.

Right: The Old Dolphin Inn on the corner of Full Street (previously Alderman Hill), May 2015. The part to the left was drastically reduced in 1958.

DID YOU KNOW...?

The Dolphin is Derby's oldest pub. Although it claims the date of 1530 (which seems perfectly plausible), documentary mentions are absent until the 1630s, and the building, which was reduced in size in 1958, dates from the very early seventeenth century.

If one notes the street opposite the cathedral, you are on another part of this late Saxon street grid. This is St Mary's Gate. At its end it joins Bold Lane (from Bolt Lane, the street of the bolt – arrowhead – makers), the parallel western equivalent of Full Street. A little further north, this makes a turn into Cathedral Road, once Walker Lane (the street of those who 'walked' woollen cloth to extract the natural oils from it). This runs back up to Queen Street, parallel with St Mary's Gate to debouch opposite the Dolphin.

If one moves further north along Queen Street (originally High Street, or the King's High Way, renamed in the eighteenth century), note two more streets that run off: St Michael's Lane to the east and, round the kink in Queen Street (where it becomes King Street) Chapel Street, both parallel to Alderman Hill and Walker Lane, respectively.

To complete a tour of late Anglo-Saxon Derby, it is necessary to engage all available imagination, as the Inner Ring Road (called St Alkmund's Way) destroyed a large part of it. It appears north in a deep chasm, but preceded between it and St Michael's Lane by a slip road and a large plastic hotel called Jury's Inn, both of which should be ignored.

The chasm replaced Medieval Bridge Gate, pitched as a new street in the thirteenth century along the line of the town ditch, so it could be argued that it is a splendid visual aid. The church of St Alkmund stood just west of Jury's Inn, and King Street goes west

DID YOU KNOW...?

The tower of Derby Cathedral (also a parish church) at 172 feet tall is the second highest for any parish church in England. It is beaten only By St Botolph, Boston, Lincolnshire ('The Boston Stump'), the upper stage of which was built as a lighthouse.

round the site of the enclave that once surrounded it, latterly Derby's only Georgian Square, St Alkmund's Church Yard – all swept away for the road.

If you cross the chasm on the modern bridge to Pugin's chastely Gothic St Mary's Church (1838–44), you can turn right and descend via a footpath to the Bridge Chapel and St Mary's Bridge, about which more anon. Cross the bridge and turn left by the Bridge Inn (of 1791) and you are in Mansfield Road. Just beyond the pub car park, City Road branches off left and if you follow that you will reach the centre of the Roman fort – 1,000 years of Derby's history in less than a mile!

Left: St Mary's Church, designed by A. W. N. Pugin. 1838, seen across the new bridge spanning the Inner Ring Road chasm, May 2015.

Right: A view from the far bank of the Derwent of the east end of the Bridge Chapel. The burgess' house (of 1700) is behind and Thomas Harrison's replacement at Mary's Bridge of 1794, taken 2011.

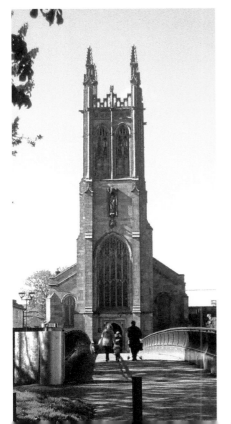

3. Evolutionary Secrets

Lost Churches

By taking a modest wander around the few remaining sites of Saxon Derby, we encounter St Mary's Gate and St Michael's Lane. Yet Pugin's fine church of St Mary is a Catholic place of worship erected in the second quarter of the nineteenth century, long after St Mary's Gate came into being. St Michael's Lane has a former church (now solicitors' offices) on its corner with Queen Street, which was indeed dedicated to St Michael. Although today's structure only dates back to 1857 (a design of Henry Isaac Stevens of Derby), it replaced an ancient church of that name which managed to collapse – fortunately just minutes after the end of Sunday morning worship – on 17 August 1856. Today there is no church in St Mary's Gate, although from 1813 to 1844 there was a small Catholic chapel.

The earliest records of Derby give us some clue. The Domesday Book tells us that there were two churches belonging to the king – effectively Royal Free Chapels. These we know were St Alkmund's and All Saints', which we have already encountered. It then tells us about a place in Derby called Litchurch (clearly implying a church) and goes on to list four churches belonging to great landowners: Geoffrey Alselin (before the Conquest, the property had belonged to Toki); Ralph son of Hubert (previously Leofric's); Norman of Lincoln (succeeding Brun); and Edric, successor to his father, Coln.

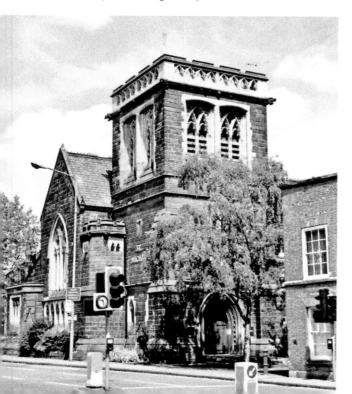

Queen Street, the church of St Michael 2006, as built in 1857 to replace the medieval edifice.

DID YOU KNOW....?

The suffix 'gate' on a street name is a relic of Viking times. It comes from the Norse *geata* meaning 'street'.

Later on we know of six churches in Derby: All Saints', St Alkmund, St Peter's, St Werburgh's, St Michael's and St Mary's – on St Mary's Gate. This last failed to survive even until the Reformation, its name fossilised in that of the street on which it was situated. Its foundations were not discovered until 1922. Oddly, six churches are also mentioned in Domesday Book, but they do not all tally with the later survivors.

Now Geoffrey Alselin was a tenant-in-chief – that is, he held his land direct from the King. Later, it emerges that the church at Alvaston, one of Geoffrey's manors, was a chapel of ease to St Michael in Derby, so Geoffrey's church must be St Michael's. Less certainty surrounds the remainder, however.

This leaves us with only one church identified. However, St Mary belonged to the pre-Norman abbey of Burton, as did a mill and a few other places in the town. To add to the confusion, the coming of the monasteries to Derby leaves us in no doubt that there had also been a church of St Helen and another dedicated to St James. The former was owned by a burgess (free citizen) called Tovi who, in around 1137, gave the church as part of his foundation of an oratory 'on his own patrimony', suggesting that he was probably a person of considerable stature, and probably of Norse descent. Around five years later, another rich burgess, Waltheof son of Sweyn (another person of Norse origin), gave his church of St James to the Cluniac abbey of Bermondsey, in Surrey. Finally, there is a distinct possibility that there may have been yet another church in Derby, dedicated to St George.

One of the two truly classic coaching inns in Derby was the long-vanished George in Iron Gate. It is first mentioned in a deed granting the lease to Edward Osborne, Gentleman, of 1648. Yet the street behind, George Yard, which runs approximately parallel with Sadler Gate, seems to have acquired its name centuries before 1648. It was called, in the fourteenth century, *Juddekynlone* (Judkin Lane), first encountered in 1343 and deriving from a now obsolete personal name. Significantly, that name, *Jud,* was anciently a north Midland and north-western dialect diminutive for George, Judkin being thus a double diminutive. As nobody bearing the name Judkin occurs in any early charter, we may be looking at another Derby secret: evidence of yet another lost parish church, presumably dedicated to St George.

Other clues lie in the shape of the lane, which appears to lead nowhere but then turns and goes back to Sadler Gate from which it originally branched. Another is in the plethora of parish boundaries which, before a nineteenth-century rationalisation, met at the apex of the lane, where it turns from west–north-west to south-west, a sure sign of some makeshift medieval arrangement, suggesting a parish church had at some stage been decommissioned and its parish divided up among surrounding ones. The same phenomenon can be traced by the site of St Mary's, last referred to in a will of 1518 when

George Yard, view south-west towards the former county council offices, September 2015. The lost church probably stood behind the bushes to the right of the tower.

it was merely a chapel. By 1536, it had vanished. Not that the George Inn necessarily took its name from such a church; more likely by the seventeenth century it had been all but forgotten (bar the name of the lane) and the inn was named after the jewel of the Order of the Garter called the Great George.

Another phenomenon is that apart from St Werburgh's, which was originally the focal point of a separate settlement, later absorbed into Derby, all these churches, lost and otherwise, were situated on or just back from the main north–south trackway along each side of which Derby grew up. They can be plotted on a map and follow a trend clearly observable in other towns.

Monastic Derby

It was mentioned that the churches of St Helen and St James were both given by their wealthy proprietors as the kernel of monastic foundations. In 1066, Derby had but one monastery, in the shape of the combined College of All Saints and St Alkmund. These twelfth-century donations began the process of expansion, and most have left vestiges that can be seen today.

St Helen, starting as an oratory, was added to by Dean Hugh of Derby – probably the superior of All Saints' College – who gave his church of St Peter plus land on the west side of the river, immediately north of the town ditch, to found an Augustinian abbey, his donation being confirmed by the chief lord, William de Ferrers, 1st Earl of Derby. This rapidly became the largest abbey in Derbyshire, named after the tiny settlement at the northern end of Hugh's donated land, Darley. St Helen's was thereupon absorbed and became the abbey's hospital. By 1159, the newly installed monks at Darley Abbey had also acquired the patronage of the churches of St Michael and St Werburgh, while the monks

of St James's had founded a hospital there as well, thus providing for the medical needs of the citizens rather more adequately than after Henry VIII abolished them, leaving people with no such provision at all.

After the Anarchy, when King Stephen fought Empress Matilda for the throne, things settled down again under the strong rule of Matilda's son, Henry II. This allowed prosperity to return, leading to the foundation of a convent so that daughters with a religious calling could be catered for too. This was set up as a sister house under the aegis of Darley Abbey at King's Mead, west of St Werburgh's church and was dedicated to St Mary, the suffix 'de Pratis' ('of the meadows') being commonly added. This too would have had a chapel, but no trace of the main monastic buildings has ever emerged, so its location remains more than a secret – it's a mystery. This priory became independent of the Abbey in *c.* 1250, around ninety years after its foundation. The only above ground remnant of St Mary de Pratis is an early Tudor brick farmhouse, otherwise No. 126 Nuns' Street, reached from Brick Street, just beside the Headless Cross. The conventual buildings were bought by the Suttons of Over Haddon and the lodgings made into a town house, but vanished altogether by the end of the seventeenth century with the exception of this one picturesque building on appropriately named Nuns' Street, restored very carefully by the University of Derby in 1996.

Also in the time of Henry II, probably *c.* 1180, a leper hospital was founded, run by monks and dedicated to St Leonard, unlike most leper hospitals, which were usually dedicated to St Lazarus. Because of the fear in which people held leprosy and its infectious nature, these hospitals were invariably in isolated country places or outside the limits of a town, hence its position well south of St Peter's (the site, Leonard Street, is in chapter 9). Indeed, its focus may have been a pre-existing church, perhaps once belonging to the otherwise unknown Anglo-Norman Luda, whose foundation gave us the toponym, Litchurch, centered just in this area. The idea that St Peter's was the original of Litchurch is topographically less convincing. Yet, like the other Derby churches, it and its chapel were on the ancient trackway that bisected Derby and ran thence south to Swarkestone Bridge.

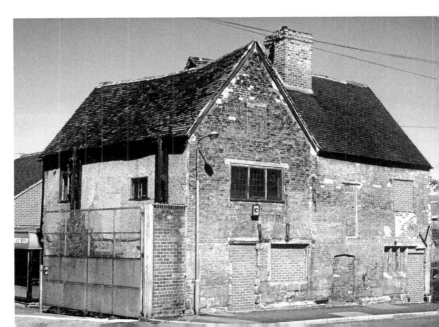

Nuns' Street, No. 126, a Tudor conventual farmhouse thought to be the only surviving vestige of the Convent of St Mary de Pratis/ King's Mead, photographed in 1980 before restoration.

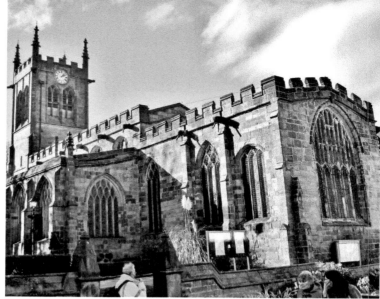

Left: Payton's Lane, an ancient way now connecting Leonard Street with Arboretum Square, June 2004.

Right: St Peter's Church from St Peter's Street, seen from the south-east, March 2016. It is the only central Derby church to retain any medieval fabric.

The final monastic foundation was a Dominican friary, set up on his urban holdings by Sir William de Verdon of Foremark, just south of the Trent. This was situated, again with a chapel, just south of King's Mead, nearer to St Werburgh's Church on what is Friar Gate. The site is marked by the Georgian Friary Hotel. By this date too, a bridge across the Derwent had been built – the first since Roman times – at the end of the town ditch, which was thereupon converted to a street named, in true Norse usage of the town, Bridge

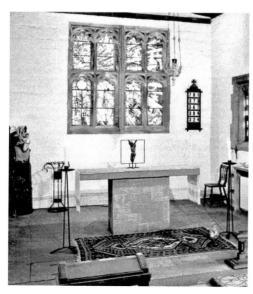

Bridge Gate, Chapel of St Mary-on-the-Bridge, interior as restored in 1930 and embellished subsequently: the window glass is by Mary Dobson and the altar by Ronald Pope (both 1973).

DID YOU KNOW...?

Today there are only six surviving bridge chapels in England, of which Derby's is one of only two in regular religious use.

Gate. At its western end was a tiny chapel, enlarged in the fifteenth century, dedicated to St Mary-on-the-Bridge.

There were also a number of preaching crosses (part of one still survives, as we shall see in the next chapter) and three known holy wells – the one dedicated to St Alkmund survives at the foot of the vertiginous, appropriately named and still cobbled Well Street, now in an early eighteenth-century stone niche and protected by a stout iron railing. Local people in nearby flats still prefer its water over that supplied by Severn Trent Water!

Of course, not all of Derby's life was dominated by religion. The town was run, until the Black Death wiped most of them out, by an oligarchy replete with relations of Hugh the Dean, the man who founded Darley Abbey. There is also the persistent use of the name 'castle' south of the Markeaton Brook. So, was there ever a castle at Derby?

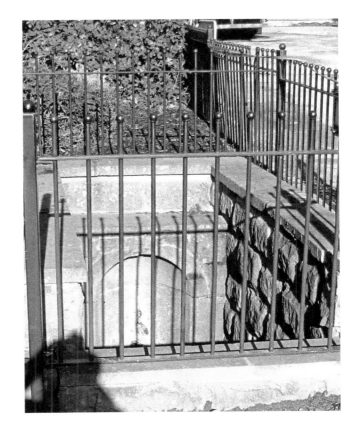

Well Street, corner of Duke Street, St Alkmund's Well, February 2016. The stonework was replaced in the early eighteenth century and the ironwork added recently.

The Lost Moot Hall

In medieval times a free-standing town hall had been built in the Market Place. However, in 1610 a new building called the Moot Hall, possibly on a very ancient site, was built set back on the east side of Iron Gate. It was tall – four storeys and a multi-gabled attic – made of brick and had mullion and transom cross windows. From then on, municipal business was conducted there until in 1731 a new Guildhall was built on the site of the medieval one in the Market Place, rendering the Moot Hall redundant. Its forecourt to Iron Gate was built over and it became a store, approached from behind a coaching inn on the north-west corner of the Market Place called the Virgin's Inn. After that, it was more or less forgotten.

In the 1930s, the council sold it to the Derbyshire Building Society, which used it as overflow offices from their premises in Iron Gate, also as storage. They fitted Crittall windows and removed the attic gables, replacing them with a flat roof. When the present Assembly Rooms were built, the approach, Virgin's Inn Yard, was altered to serve the loading bay behind the new building, and once again the old Moot Hall was revealed, still with its characteristic early thin brickwork. Access may be difficult, but it can still be seen in its secret little enclave behind the Assembly Rooms.

All that is visible of the 1610 Moot Hall, immured by later buildings and difficult to find, June 1997. The site is probably much more ancient, possibly going back to the *portmannemoot* held in the tenth century.

A Lost Castle

The name 'Castle Gate', as applied to East Street (previously Bag Lane), was a red herring arising from a mistaken quotation in Camden's *Britannia* (1610) and should not be included among the circumstantial evidence for there ever having been a castle at Derby. Indeed, no word of a castle appears in any state records, although any official structure of this sort would inevitably find itself on the written record somewhere in the public domain. As a result, many commentators have taken the path of caution and let the matter lie as not proven.

Others have suggested – on the basis that the name Copecastle (in its later guise as Cockpit Hill) is shown on John Speed's 1610 map of Derby as a strange little structure actually on a mound – that a natural feature inspired the epithet of castle, as elsewhere. This does not explain some earthworks seen by William Hutton in the eighteenth century, but these could represent Civil War defence works. As they apparently ran north–south, rather than the tactically sensible east–west, this would appear unlikely.

The recent discovery in 1988 of an 'adulterine' castle (i.e. one built hastily, without licence from the Crown) beside the Norse defences at Repton however, suggests that at Derby, too, such a strongpoint might well have been established. The builder of that at Repton was Ranulph, Earl of Chester, on his own manor. Having taken the initiative on behalf of the Empress Matilda against King Stephen, winning a considerable victory at Lincoln in 1141, Ranulph seems to have re-established control in the Trent valley in the process of trying to realise his ambition to connect his palatine county of Chester to his extensive Lincolnshire estates with a chain of strongpoints from sea to sea to create an independent duchy for himself. Indeed, in 1149, Ranulph was granted 'the town of Derby and what belonged to it' by Matilda, confirmed in 1153. If such was the case, no official record would remain of any hastily constructed castle and, unlike his castles at Repton and Castle Gresley, most archaeological traces would also have vanished beneath the later town. Its position would most likely have been at the south end of the Morledge, on Cockpit Hill, where topographical evidence provides some corroboration.

View south along Morledge towards Cockpit Hill, 15 October 2015. Although now the site of Eagle Market, this is the area where the so-called adulterine castle would have stood.

DID YOU KNOW...?

St David is said by his biographer to have founded the first monastery at Repton, just 7 miles away.

The Derby mint, a silver penny struck by Walchelin of Derby during the Anarchy, probably working at the behest of the Earl of Derby, for whom he also struck coins at Tutbury. (The late Roy Hughes)

The edifice, almost certainly a wooden structure, its chapel and its earthworks, would have been razed when Henry II came to the throne in 1154, ending the Anarchy and reasserting control. At the same time, he also abolished Derby's prolific mint, run by Walkelin de Derby, another of Dean Hugh's numerous relations. He must have made a small fortune in that role however, as he is said to have given land to endow a school to be run by Darley Abbey.

St Peter's and Beyond

Some 150 yards up St Peter's Street lies Derby's only surviving church with any medieval fabric also surviving. This is St Peter's itself, once the patrimony of Hugh the Dean and the burial place of England's first medically trained gynaecologist, the very upper crust, Dr Percival Willoughby MD (1596–1685). The church was rebuilt in stages by G. G. Place of Nottingham in 1852 (G. E. Street a little later) and the nave and tower were rebuilt by J. H. Lloyd in 1898. But despite that, a surprising amount of the fabric that survives is medieval, as is the general appearance, with the chancel almost protruding into St Peter's Street. On the north side of the churchyard is the remains of the 1672 Green Man Inn (now inappropriately called Ryan's Bar) with its tall brick Dutch gable, although the remainder was mainly lost in the 1936 fire. On the far side of the church, off the south side of the churchyard, is a modest, early seventeenth-century stone building. As well as granting the people of Derby Nuns' Green, Mary I also endowed a grammar school from appropriated monastic property in 1555, although this slightly later building, sympathetically and tactfully extended in the 1980s, is now a ladies' hairdressing emporium.

Here medieval vestiges rather peter out for, although the leper hospital of St Leonard lay further south, nothing survives of it except the name Leonard Street, and even that is only an attenuated remainder of the residential thoroughfare laid out for a housing club in 1807, although St Leonard's Close was recorded there in 1557 and in 1713 it was still so called. Nevertheless, Payton's Lane (*see* page 26), connecting St Leonard's to Arboretum Square, is a vestige of an ancient way, as is Drewry Lane, which starts on the inner ring road as a street of terraced houses but becomes an almost bucolic footpath skirting the Uttoxeter New Road cemetery to end at the Rowditch, the site of a vanished settlement which once lay beside Roman Rykneild Street.

Drewry Lane, looking west from Peet Street near the Uttoxeter New Road cemetery, 20 February 2014.

4. Forgotten Alleys, Secret Places

It is one thing to describe the complexities of Derby in the medieval period, but another to get an impression of it on the ground. Nevertheless, this is perfectly possible and reveals numerous secret corners of Derby. Furthermore, it reinforces the fact that the street layout in the core of the city is of medieval origin and is largely unchanged, apart from some judicious widening in more modern times.

A Marble Works and a Swimming Pool

To start, one has to move from north to south, which necessitates taking up a position in King Street, with one's back to St Helen's House, Derby's incomparable Grade I-listed Palladian town house, designed by local architect Joseph Pickford and built in 1766–67. It is no coincidence that after it became the Derby Grammar School in 1861, a chapel was built by old boy Percy Currey in 1894–98 and dedicated to St Helen, after whom the house was named. The latter was because after the Dissolution of the Monasteries in 1536–39, the name of the hospital of St Helen and the church around which it was founded lingered on, as the site was acquired and a town residence was built upon it and occupied by a succession of landed proprietors from the county. One of these was William FitzHerbert of Tissington Hall, who lived at Old St Helens when in Derby, and where his younger son, Alleyne, was born. He was later a diplomat of international standing, and was, in 1801, created 1st Lord St Helens, taking his title from the house in which he was

King Street, St Helen's House, seen through the modern gates, 20 May 2015. Built in 1767 for John Gisborne MP by Joseph Pickford, is was rescued from years of local authority near-dereliction by Richard Blunt and is now HQ for a leading firm of accountants.

born. When the family ceased to need it in 1772, a twenty-one-year lease was sold to the internationally famous Derby-born painter Joseph Wright ARA. Ironically, after he left, and just when Lord St Helens was being elevated into the peerage, the house was in the process of demolition by spar turner Richard Brown, who used the cleared site as his marble works.

When in its turn the marble works, opposite St Helen's House on the corner of St Helen's Street, was demolished in 2006 to dual the road, excavations revealed no trace of the lost church. What it did reveal though was Derby's first public swimming pool dating back to around 1806, heated by the waste heat from the steam engine that was installed to drive the machinery invented to saw and turn Blue John, Ashford Black Marble and other fine spas into exquisite ornaments. That no church appeared suggests that the church and conventual buildings lay a little further back, or a little further north, where the original spar turning block still stands, albeit spoilt by uPVC windows. When the ground just behind was being excavated however, the town ditch was found (*see* chapter 2), its alignment demonstrating that the church had lain fractionally within its line.

From King Street, turn left, following the curve into now pedestrianised Bridge Gate, and one arrives at St Mary's Church, built at the expense of John Talbot, 16th Earl of Shrewsbury, in 1838 by Augustus Pugin. Note the house to its left, now part of the Convent of Mercy, built by the Gisbornes in 1732, who later built St Helen's House.

Cross the modern footbridge over the chasm which contains the Inner Ring Road, and try to remember that it more or less follows the line of the town ditch, Derby's original northern defence. Beneath the hideous plastic Jury's Inn hotel lie the remnants of the successive churches of St Alkmund, demolished in 1966–67. Indeed, the excavation of the church site shed more light on the origins of the city than any other, before or since.

Above: Richard Brown's marble works: the original 1802–06 range looking towards King Street, before the latter was dualled, 1987. The building is currently boarded up.

Right: Marble bust of the eminent diplomat Alleyne FitzHerbert, 1st Lord St Helens (1753–1839) born at the original St Helen's House and from which he took his title. (Photographed by kind permission of Sir Richard FitzHerbert Bt)

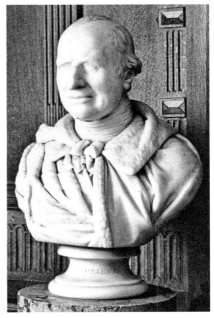

DID YOU KNOW...?

Lord St Helens also gave his name to Mount St Helens, Washington State, USA, which catastrophically (and televisually) erupted in May 1980. Thus the name of this far-off mountain derives directly from a pre-Conquest parish church in Derby.

Queen Street and St Mary's Gate

Once across the footbridge and the road beyond, one is in Queen Street. To the left is the Victorian church of St Michael of 1857 (*see* chapter 3) and built from stone blocks horizontally grooved and now offices. This is the church taken over by Geoffrey Alselin from the Anglo-Norse grandee Toki. Its redundancy in the early 1980s reflects the flight of residents from the ancient town centre to be replaced by commercial interests. Strangely, now the retail epicentre of the city has been (perhaps most injudiciously) moved successively southwards from the Market Place, landlords are beginning to realise that the only way to revive this part of the city is to allow properties to revert to the residential use

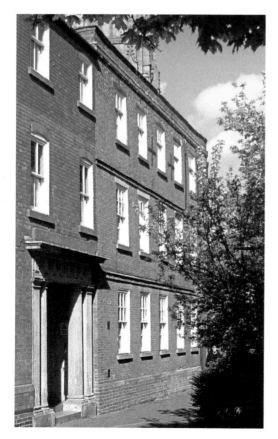

Convent of Mercy, Bridge Gate, 20 May 2015. The 1731 building was rebuilt in 1767 by Joseph Pickford, whose classical doorcase remains (left) in an early twentieth-century extension.

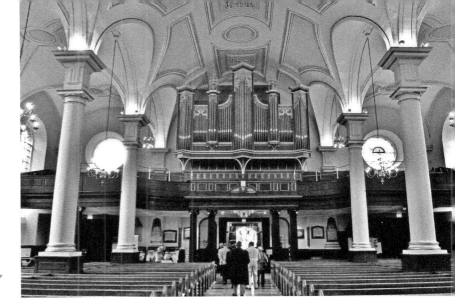

Queen Street, All
Saints' Cathedral
church, interior
view looking west
toward the gallery,
15 September 2015,
after redecoration.

for which most of them were designed. The church was saved from possible demolition by a tactful conversion into studios by architect Derek Latham.

From St Michael's, the enormous bulk of the early sixteenth-century tower of All Saints (now Derby Cathedral) becomes apparent. There is nothing surviving from medieval times here except the grid-like pattern of roads running off Queen Street on each side, described in chapter 2. The bulk of the church, a tactful 1723 baroque design by James Gibbs, simplified from his St Martin-in-the-Fields, does however rest on the walls of its medieval predecessor. Either side run the pair of medieval alleys, College Place and Amen Alley (*see* chapter 3), the latter home to one fine Georgian house and a car park. They say it got its name because at the Full Street end there was a shop selling missals in medieval times. However, the medieval building, which survived on the spot until 1870, was a pub named the Bath Inn. Perhaps the Reformation forced a diversification!

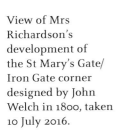

View of Mrs
Richardson's
development of
the St Mary's Gate/
Iron Gate corner
designed by John
Welch in 1800, taken
10 July 2016.

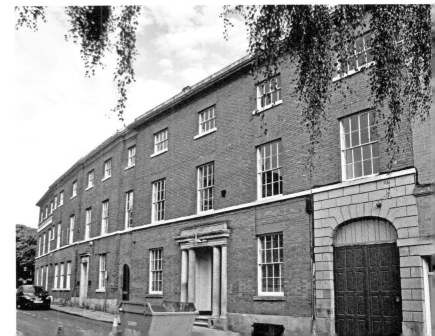

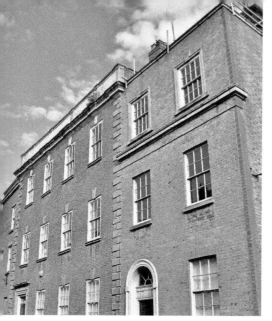 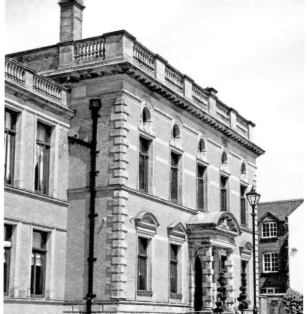

Left: St Mary's Gate, town house of Hugh Bateman of Hartington, built 1731 and extended at each end in the late eighteenth and early nineteenth centuries. (Photographed 10 July 2016.)

Right: The St Mary's Gate Hotel, formerly County Education Office, by John Somes Story, 1908, converted into an hotel in 2009–10. (Photographed August 2011.)

Opposite is St Mary's Gate and the lost church of St Mary was discovered when the foundations for the 1920s office building (St Mary's Chambers), opposite the cathedral, were being put in, the works being the result of widening Queen Street.

It is worth descending St Mary's Gate, one of the finest streets remaining in Derby. The houses on the left, down to and including No. 40, were built by architect John Welch in 1800 as an investment for a banker's widow, Mrs Richardson. Beyond is the mid-nineteenth-century Probate Court and next to it, Nos 34–36, once the town house of the Bateman family of Hartington Hall, and the only Derby town house to retain its garden. Beyond the St Mary's Quarter Hotel (formerly the county education offices of 1908) is a stunning set piece which may well have had medieval origins – the current magistrates' courts.

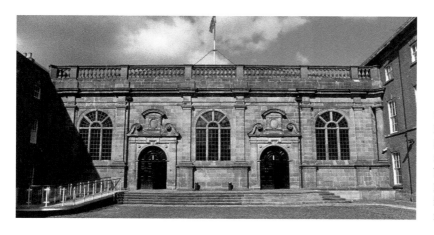

St Mary's Gate, Derby's superb Shire Hall of 1659–60, designed by George Eaton of Etwall and restored in 2005 as the magistrates' courts.

The former King's Arms County Hotel built in 1798 for the benefit of plaintiffs and attorneys attending the assizes, then held in the Shire Hall, now part of the magistrates' courts, 10 July 2010.

The central stone Grade I-listed building, once free-standing, was built in 1659–60 as the shire hall. In the eighteenth century, its convivial and administrative functions were gradually overtaken by its judicial ones, and in 1772 a grand jury room was added, followed by the wing of the left, once the King's Arms County Hotel (the stucco inn sign remains on the wall facing the street) in 1795. The corresponding wing on the other side of the wide cobbled courtyard was added as the Judges' Lodgings in 1809–11, again to John Welch's designs, and the entire complex was extended at the rear by Matthew Habershon in 1826, although the latter has almost all been demolished to allow more room when the complex ceased to be a Crown Court and became magistrates' courts. Only Habershon's two courts survive and there is a fine bust of F. N. C. Mundy by Sir Francis Chantrey. It is possible that the site had a communal use prior to 1659, although no record survives of this. Apart from Lincoln Castle, it is the finest surviving Classical legal complex in the Midlands.

St Werburgh's

At the bottom of St Mary's Gate, avoid being deterred by a multi-storey car park opposite and cross, moving to the left where you will soon encounter St Werburgh's church, redundant since 1990, although partly in the care of the Churches Conservation Trust. This part, built to designs by Henry Huss in 1699, is the first portion one encounters in this direction, and formed the chancel of a church, most of which was replaced to a design by Sir Arthur Blomfield in 1893–96. Here, Dr Johnson married Tetty Porter on 9 July 1735, and here Robert Bakewell, England's finest native-born wrought ironsmith, supplied an elaborate iron cover for an equally elaborate brass font shaped like an eagle. The former is there to be admired; the latter has vanished. The remaining ironwork is by talented Arts and Crafts revival smith Edwin Haslam, done in the 1890s. Also inside is another fine monument by Derbyshire-born Chantrey to Sarah Whinyates of Chellaston (1835) and a gilded Queen Anne timber reredos of remarkable competence by Henry Huss himself.

If one goes around the church (admiring on the way the wrought-iron gates with the Borough arms by Bakewell's assistant, Benjamin Yates), one arrives at the junction of The Wardwick with Cheapside (part of St Werburgh's Church Yard, renamed in 1791), Friar Gate and Curzon Street. This was the centre of the once separate village of Wardwick, absorbed into Derby prior to 1086 but which is remembered by the survival of its name as

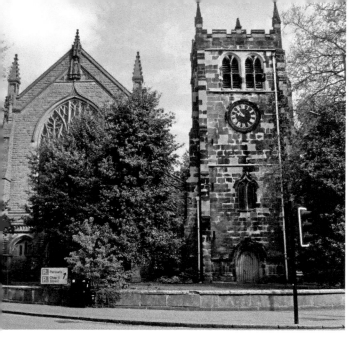

Friar Gate, St Werburgh's church. The tower was built in the first decade of the sixteenth century, and the nave is the work of Sir Arthur Blomfield, 1896–98, replacing a fine classical church by Henry Huss of 1699, photographed 10 May 2016. The original church was the centre of a small settlement predating Derby called Wardwick.

the street connecting to Victoria Street. The church was once the parish church, and there was an important mill, owned by the Abbey of Burton, just behind the church.

A diversion along Friar Gate

Those keen to investigate the two outlying monastic sites need, at this juncture, to proceed along Friar Gate, which of course takes its name from the Dominican friary around 500 yards along on the south side. When it was dissolved by Henry VIII, a Derby burgess called Bainbrigge acquired the site, demolished the buildings and erected a very large timber-framed house. This was replaced by banker Samuel Crompton in 1731, but the old house was left standing – in the back garden as it were – divided as tenements until the leases fell in, and it was finally cleared away in 1760. The new house, built in front of the old, has only half a cellar. When the place was being constructed, vast quantities of buried bone was encountered under the western half of the house, and it was decided to leave the poor monks' remains in situ, so only the cellarage on the east side was completed. You can still see that the cellar windows on the right of the entrance to what is now an 'entertainment venue' are blind. A map of 1712 clearly marks 'ye monks' burial ground' where the new house was, so the cellarage confusion could easily have been avoided!

The house was extended and embellished in 1760–63 and again much enlarged in the 1880s by Henry Boden, a lace millionaire and his wife. Mrs Boden was a magistrate and a keen temperance enthusiast, one of those people who always know what is good for other people, especially those less well favoured than themselves. She once attended an election rally for Michael Thomas Bass, the Burton-on-Trent brewery proprietor who was MP for Derby. At the end of his peroration she shouted up, 'What have you ever done for temperance Mr Bass?' 'My beer is always well wattered madam,' he shot back.

Nevertheless, as chairman of the Bench in 1908, she managed to force the closure of over thirty small pubs in the town. Ironically, when widowed, she decided to move to

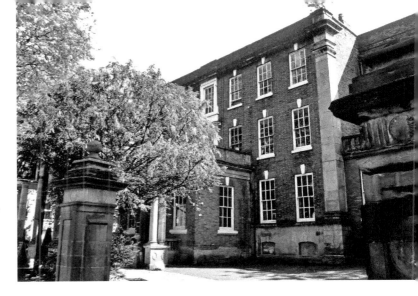

Friar Gate, the Friary, seen 1 June 2014. The original building stood in the courtyard behind the present building, which was begun by Richard Jackson of Armitage in 1730. It was enlarged *c.* 1764 by Joseph Pickford, in 1875 by F. J. Robinson and again, *c.* 1905, by Alexander MacPherson. It has been licensed premises since 1921.

Chard and sell the huge house. It is reported that she was outraged when she discovered that it had been bought as a hotel in 1921, and would, naturally, be licensed!

From the Friary, one proceeds further west along Friar Gate. Until the nineteenth century, the north side beyond Ford Street was known as Nuns' Green, for it was the King's Mead pastureland that the Convent of St Mary de Pratis had enjoyed. The convent was closed in 1536, but when Queen Mary came to the throne, she realised the Dissolution was something that could not be reversed after nearly twenty years. But the Crown still held the fields of the convent, and she bestowed them on the burgesses of the town, and became something resembling a public park or common until 1768 and 1792 when Improvement Acts were obtained to sell the land off for building, which resulted in the line of elegant Georgian residences on the north side.

At the end of Friar Gate, the street widens out, for here until 1861 was the beast market. The area was surrounded by numerous pubs there to enable thirsty farmers to slake their thirsts.

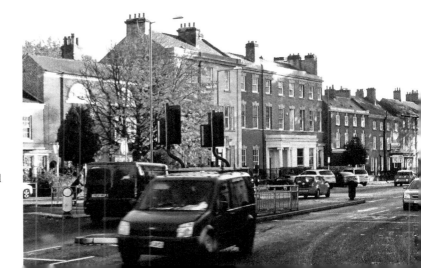

Friar Gate, looking south-east from Uttoxeter Old Road/ Ashbourne Road junction, 19 November 2013, showing the width of the street, where, until 1861, the beast markets were held.

DID YOU KNOW...?

An iron bullring remains set in the pavement outside the Greyhound pub in Friar Gate, a sole reminder of the beast fairs held there weekly until 1861.

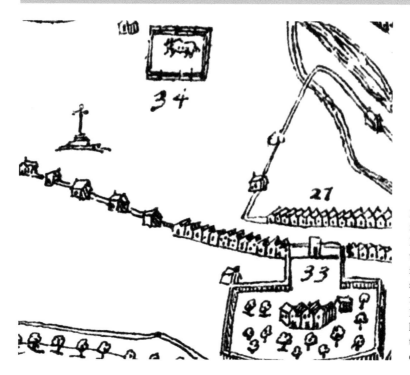

Detail from John Speed's map of Derby showing the headless cross intact on the north side of Friar Gate, 1610. Note the Friary, set back, lower right and the pinfold, upper, centre.

Most became redundant after a new market was built and Mrs Boden closed most of them – only the late eighteenth-century Greyhound survived, its rather butchered facade having been put on by the ubiquitous architect and builder John Welch, who married the landlord's widow.

Further along, on the other side, is the Headless Cross. John Speed's map places it here in completion, but it later lost its cross (probably in the Civil War) and it ended up in the Arboretum, laid out in 1840, being repatriated from thence in 1982. The story that the hollow at the top was filled with vinegar to disinfect coins on market days during times of plague is inherently unlikely but possible.

George Yard: A Forgotten Byway

For those keen to remain in the city centre in their quest for vestiges of medieval pietism, it is necessary to leave St Werburgh's and proceed left along Cheapside Cross, The Strand/ Bold Lane via Sadler Gate Bridge (still there, beneath the surface of the road) and in Sadler Gate (in width a typical medieval main road). Turn left through an arch below the

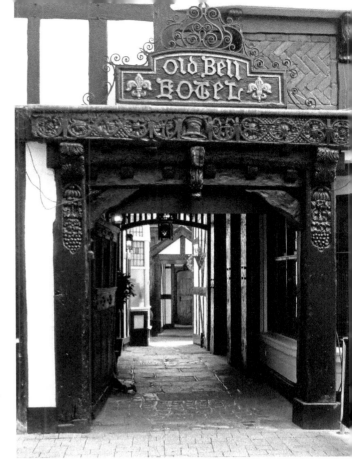

Sadler Gate, the Old Bell Hotel. The building dates from *c.* 1685/90, but was refaced in architecturally salvaged timbering by Messrs Ford & Weston in 1929. The carriage entrance, photographed 11 September 2015, is a riot of borrowed plumage. It was Derby's last functioning coaching inn, and was currently undergoing a careful restoration.

cast-iron sign high up reading Sadler Gate Bridge, a telling survival from before the 1870s culverting.

If one turns left into Sadler Gate from George Yard, one enters the Market Place by passing the fine facade of the Bell Hotel of 1693. Originally brick and gabled, it is Derby's last surviving coaching inn and has some fine (mainly later) interiors and a superb oak staircase. In the 1920s, it was rebuilt with a so-called Tudor bar at the rear (recently restored) and with a main facade smothered in reclaimed timber framing and rainwater goods, originating from a variety of now lost sources. It is undergoing a thorough and sensitive restoration after decades of neglect. If you go through to the rear yard, the south facade, unadorned with borrowed plumage, most closely gives a taste of what the street front once was like.

Market Place and Corn Market

Derby's Market Place was formed after the Domesday survey (*c.* 1100) and much of it was controlled by Darley Abbey in the twelfth and thirteenth centuries. A theory that a market area had previously existed near Sadler Gate Bridge (the *wic* from Latin *vicus* meaning market in 'Wardwick') is unprovable at this remove. Yet the existence of a church 50 yards south of the area, St James', the remains having been found in Corn Market south of St James' Street (previously Lane) when the King's Head hotel was demolished

to widen it in the 1850s, suggests that the whole area was built up or in use at the time, if not pre-Conquest. Moving south again down the spinal road, here Corn Market, the thoroughfare, opens out again as at the west end of Friar Gate. Here was the market area for grains, assayed in stoups, metal bowls on 2-foot supports at the sides of the road. In 1863, the opening of the Corn Exchange around the corner in Albert Street removed the need for *en plein air* trading.

Where the street crosses the end of Victoria Street has long been a bridge, latterly St Peter's Bridge (because it allows passage to St Peter's Street, the next section of the settlement's spinal road) but called from the sixteenth-century Gaol Bridge on account of the brick-built county gaol constructed at the angle with the now culverted Markeaton Brook, where prisoners were said to have drowned in the lower cells at times of flood. To leave Corn Market and go across the bridge, one had to pass under an arch in a screen across the road, which vanished with the prison in 1755. The last version of the bridge, designed by clever old William Strutt FRS (1756–1831), deprived of its ornamental balustrade, still lingers beneath the road surface, causing a distinct hump best observed when standing outside the HSBC building and looking towards the elegant William IV Royal Hotel building which replaced the gaol in 1835–39.

Victoria Street, former Royal Hotel, by Robert Wallace, 1837–39 and closed 110 years later, photographed from the bottom of St Peter's Street in 2008. The hump in the road is due to the presence of St Peter's Bridge beneath the carriageway.

5. The Secrets of Turbulent Times

The lead-up to the Civil War in the seventeenth century did have one beneficial effect: it gained the borough a mayor. In earliest times, there was a pair of *praepositi*, a term later anglicised as bailiffs, elected together for the year for all the world like a pair of ancient Roman consuls. Despite renewing the borough's charter at the beginning of each new reign, the system still pertained in the 1630s. However, in 1637, Charles I was moving north to treat with the Scots over the reimposition of bishops. Needless to say, he needed funds for this tricky mission. He was put up in a large house on the north side of the Market Place, built by Bess of Hardwick and then owned by her grandson, the Earl of Newcastle. Newcastle was the host of a lavish feast in the 'Great Room on the Market Place', a south-facing first-floor saloon overlooking the Market Place, paid for by the burgesses of the borough, at which they petitioned the king for a mayor and various other privileges.

Derby Gets a Mayor

The king was pleased to do so on payment of a fee (called a fine) and a new charter was inaugurated and Idridgehay landowner Henry Mellor became the first mayor of Derby (although he failed to outlive his term of office). After the Civil War, Newcastle, by now a duke, rebuilt the house and gave the Great Room an exuberantly decorated ceiling. Astonishingly, the city council allowed this important building to be demolished to make way for new Assembly Rooms in 1971, although most of the later ceiling was recovered and installed in part of the building. However, since 2014, the Assembly Rooms have been closed and are to be replaced by a new entertainment venue. What the fate of the ceiling will be is quite unknown.

During the subsequent Civil War, Derby was initially a Parliamentary island in a Royalist sea, having been seized for the rebels by landowner Sir John Gell, Baronet of Hopton Hall. He installed his brother Tom Gell as MP and left a radical henchman called Thomas Sanders to run the town. At this time, the Gells built, a fine brick three-storey town house in Friar Gate in Derby which miraculously still survives. It stands opposite the Friary (*see* chapter 4) and although it has lost its pedimented doorcase to shopfronts, and suffered its windows to be modernised, it is still a fine example of a gabled brick house of the period, although the upper floors are now let as flats. Despite being less ornate than the better-known 'Jacobean House' in The Wardwick (currently unoccupied), it is more complete.

Gell fortified St Mary's Bridge and built numerous earthworks (some of which may have been mistaken for vestiges of the lost castle a century later), but no trace of these survive. Nevertheless, it was during the Commonwealth that the magnificent Shire Hall

Friar Gate, Sir John Gell's town house, 12 April 2012. Apart from the insertion of early eighteenth-century sash windows and the shop-fronting of the ground floor in the mid-nineteenth century, it is largely unspoilt, with some good panelling remaining inside.

in St Mary's Gate was begun (*see* chapter 4), and the Restoration of 1660 ushered in a period of prosperity which was to last many decades.

Although the first mayor of Derby had a new ceremonial mace made to dignify his office, at the Restoration it was remade or replaced and the rather splendid silver-gilt

The mayor's chain of office. Unlike the mace, this is a later addition to the municipal civic regalia, although it is thought that the collar of SS may well predate the 1660s.

Market Place, Franceys's House, built in 1694 and once with a roof lantern and a frescoed ceiling. It was divided up as shops and offices in the 1930s. (Photographed in 1984.)

result is still part of the city's considerable collection of civic plate, although the experts are still arguing whether the mayor's collar of SS is late medieval or a later replacement, but it too is rare and valuable. These treasures can be viewed in the present council house, although permission and an appointment needs to be sought.

The Town Rebuilt

There are several buildings completed during this period of prosperity that still survive. Market Head (the part of the Market Place on the west) is home to most of them. The best is Franceys's House, an eight-bay-wide, three-storey brick house with an attic storey above the cornice in the manner of Sir Christopher Wren. The roof once sprouted a tall glass lantern and cupola. This was finished in 1694 for an apothecary who knew all the secret ailments of the local gentry; consequently his son was the only tradesman allowed into the assemblies.

A similar house adjoining was demolished in the 1930s, but another, probably by the same architect, is on the corner of Market Head, Sadler Gate and Iron Gate, now Lloyd's Bank. Although it has lost its hipped roof, and gained a typically bank-style ground floor, it still makes an impression, as does the next-door facade. This is now painted two different colours, and its usage is split between a pub (Mr Jorrocks) and a rather good music shop, but once masked the George Inn (*see* chapter 4) and when new in 1693 encroached upon

Above: Iron Gate, Lloyd's Bank, formerly Alderman Drewry's House, built *c.* 1700 but given a new ground-floor facade in the 1870s and a flat roof in the early 1950s. (Photographed in winter 2007.)

Below left: Wardwick, Mundy House, built *c.* 1695 for the Mundys of Quarndon, seen April 1995. It was enlarged and adapted by Edward Miller-Mundy, MP of Shipley Hall, *c.* 1780 and converted into shops at the end of the nineteenth century.

Below right: Wardwick, the Wardwick Tavern, photographed June 2008. It was built in 1708 for Thomas Allsopp, but for most of its existence it has been brewery offices, but was converted as a pub in 1969. There are parts of an earlier stone building visible inside and out.

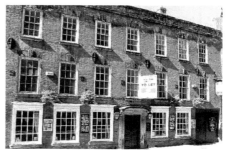

the public highway by 6 inches, resulting in a fine. Much of the building behind is earlier and timber framed.

The stucco window surrounds of these three buildings are all very similar, as are those on a similar house in the Wardwick, also built in the 1690s. The latter is now identifiable as home to the Cats' Protection League charity shop, but has a (now virtually invisible) Restoration rear projection, but was modernised for Edward Miller-Mundy, MP of Shipley Hall by William Lindley in 1799 and was rather butchered when it became shops.

If we remain in the Wardwick, the house next door but one is also a notable surviving result of the economic post-Restoration boom. Now a pub called the Wardwick Tavern, it was built in the latest London style in 1708 for Thomas Alsop or Allsopp, a merchant with a parapetted roof and a wonderfully elegant and subtle facade. It later became brewery offices (with a huge brewery behind), coming eventually into the hands of Messrs Ind Coope and Allsopp, a firm founded by Sir Henry Allsopp (later 1st Lord Hindlip), by coincidence a direct descendant of the man who had built the house in the first place. There are some good interiors on the enfiladed first floor, and vestiges of a much earlier house in the bar.

Ancient Inns

Yet if the visitor to Derby wishes to see a pub of this era, two others offer themselves. En route from the fine houses at Market Head to those in The Wardwick, one needs to travel down Sadler Gate, a non-widened main road by medieval standards. Almost as soon as one starts out, one encounters, on the left, a fine timber-framed facade. This is Ye Olde Bell, Derby's last surviving coaching inn, founded in the 1680s and originally, like Thomas Gell's House, of three storeys, brick with gabled attics (*see* also chapter 4). Go through the carriage entrance (past a door on one's right leading to the original oak staircase, Derby's finest of this date) to the inner courtyard and look up and one can see the original fabric of the building. The smothering of timber and stucco was a cosmetic addition of the 1920s when the inn was 'modernised', as was the little Tudor bar at the rear, a wonderful confection of the same date, now carefully restored, which until the 1980s was a 'men only' bar. The former ballroom on the side of the courtyard is a nineteenth-century room of no little pretention, also recently restored after decades of neglect.

Next door to the Bell is what looks like an early nineteenth-century building but which has a gabled Restoration facade at right angles to the road. Next door again, No. 48 has another stone pedimented doorcase dated 1675, part of the facade of a four-bay, four-storey house with its original cross windows upstairs.

A final watering hole of this date is the Seven Stars in King Street, almost opposite St Helen's House. The brick building (painted to look like timber) is dated 1680, although the history of the pub cannot be pushed back that far – though by no means impossible. Like the early seventeenth-century Dolphin, further towards town in Queen Street, it still has the intimate feel that pubs used to have. The Seven Stars, originally the Plough (the constellation rather than the implement), was from 1849 to 1935 virtually next door to the Derby King Street China factory – the firm set up by redundant employees of the original Crown Derby company, closed in 1848. Nothing really remains of this now, but in its heyday the pub served its beer in Crown Derby pint and half-pint tankards of at least two different designs, now very scarce.

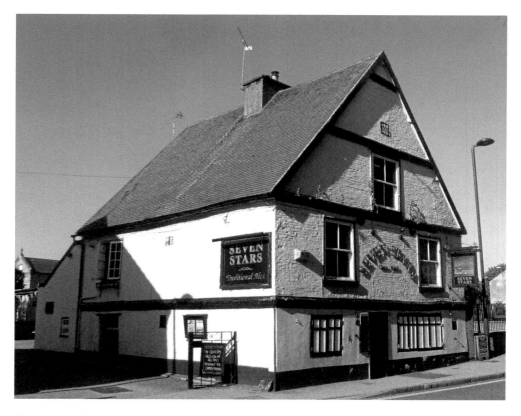

King Street, the Seven Stars inn, dated 1680 and a pub since the mid-eighteenth century,
9 September 2015.

Politics Rears Its Ugly Head

No one who has proceeded to Full Street, the new Premier Inn or the Silk Mill will have missed the fine equestrian statue of Bonnie Prince Charlie, accompanied by a plate recording Dr Johnson's memorable comment of the forty-five: 'It was a noble attempt.'

From the Revolution of 1688 (instigated by Derbyshire grandee and town High Steward, the 1st Duke of Devonshire, among others) to the 1740s, Derby was seriously divided. The hereditary elite, who held a virtual monopoly of power, were incorrigible Whigs, very much the Duke's men; yet most of the more modest tradesmen were Tories, disenfranchised by the manipulation of the vote at elections. This led to much dissent, although at a particularly crucial election in 1741, the Tory candidate, landowner German Pole of Radburne Hall, having been denied victory through the simple expedient of the (Whig) returning officer closing the polls early before the (Tory) farmers, in to vote, had finished refreshing themselves in the pubs, sensibly urged his followers, hell-bent on causing mayhem, to accept the verdict. In recompense he laid on a feast for them at his home instead, which appears to have mollified the majority.

When, in September 1745, it was realised that the Scottish army, under Prince Charles Edward Stuart, was heading south, the Duke of Devonshire organised a hastily raised militia unit called the Blues, mainly consisting of the tenants and labourers from the

estates of the county's gentry. Most of the gentry agreed, but when the chips were down, and the Prince's arrival imminent, many Tory landowners failed to contribute. In the event, the Blues fled to Nottingham (many getting drunk en route) and then to Mansfield, where they almost attacked a field of cows in the dark, their hungover piquets thinking that the sound of them moving about was the enemy approaching. In short, they became a laughing stock.

On 4 December 1745, Bonnie Prince Charlie entered the town via Sadler Gate and had himself declared Regent and his father proclaimed James III and VIII in the Market Place. He settled in a vast mansion built a generation before on the edge of the Derwent by an out-of-town bigwig, Exeter House. By and large, the loot and pillage that the remaining citizens were rather expecting failed completely to materialise, despite the loss of the borough's officials and members, most of whom had fled. Indeed, contemporary accounts suggest that people got on remarkably well, despite the fact that nearly 8,000 men had to be accommodated, including the prince's aristocratic officers and staff.

On the evening of 5 December, a decision was made to return to Scotland – as it happened, a fateful one – leading to the eventual defeat of the rising. Reconnaissance had proceeded as far south as Loughborough (a very Tory and Jacobite town), but no news of reinforcements was forthcoming. Had they pressed on and taken advantage of surprise, the outcome might have been very different, but their intelligence was inadequate and they also believed some seemingly potent false intelligence. A ball was held afterwards in the 1713 Assembly Rooms in Full Street and the withdrawal began before first light on 6 December.

None of the Whig elite came out of the affair with any credit, yet despite recent attempts to paint them in more favourable colours, the lack of subsequent rancour suggests a spirit of reconciliation managed to prevail as notable as German Pole's four years before.

In the run-up to the 250th anniversary of Derby's only direct brush with international political events, it was agreed that a statue would be desirable. The late Lionel Pickering, a free newspaper magnate, philanthropist and brave owner of Derby County FC agreed to be patron of a fundraising campaign. In the end, he ended up paying the lion's share of the cost of the very fine bronze statue by Anthony Stones, one of the few equestrian statues erected since the war.

Wardwick, Derby Museum, Bonnie Prince Charlie Room, 1996. The panelling came from the room in Exeter House in which the prince held his fateful council meeting, 5 December 1745.

DID YOU KNOW...?

The panelling from the room in which Bonnie Prince Charlie took his decision to return to Scotland was saved when Exeter House was demolished in 1854 and now lines a special room on Derby Museum set up to commemorate the event, complete with a figure of the prince reading out a letter to his father.

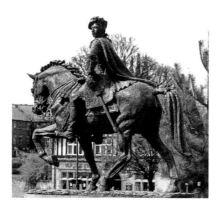

Full Street, equestrian statue of Prince Charles Edward Stuart by Anthony Stones, unveiled 4 December 1995, exactly 250 years after the event. (Photographed May 2014.)

The original idea had been to install the statue in the centre of the Market Place, the horse facing west and the prince looking wistfully southwards, towards London. The council had been keen supporters of the commemoration and had agreed a programme of event to mark it, quite apart from the statue. Yet a change of control two years before 1995 led to a new party, very suspicious of the whole idea, and somehow convinced that Bonnie Prince Charlie was some kind of potential fascist. It was explained to them that he had published a manifesto embracing fixed-term parliaments, an independent Scotland and Ireland under the Crown, and complete religious toleration (unheard of in mid-eighteenth-century Europe) but it was hard work. They refused to tolerate the Market Place position and Prince Charlie's current position, hidden behind the cathedral (where he had attended Anglican Holy Communion on the morning of 5 December 1745) is the result of the subsequent compromise.

DID YOU KNOW...?

The Market Place did not become a clear, open space until 1877. From medieval times until 1828, the Guildhall stood on the south side, facing north, beside the Shambles (where meat was sold), which faced Market Head. In 1692, a domed cupola was provided to protect the water supply and in 1708 one of the country's first true shopping centres was added, with colonnaded ground-floor shops and warehousing above. Strangely, it was never popular.

6. Secrets of an Age of Excellence

The period from the Restoration until the 1760s also saw a great flowering of creativity in Derby. Still then a thriving market town, the county gentry began to really drive prosperity. Although Derbyshire landed estates were generally small, they were exceedingly prosperous, having beneath them reserves of coal, lead and fluor spar. Suddenly, minor gentlemen with land on the east and south of the county suddenly became coal owners, and with increasing demand, lead was creating some impressive fortunes for those in the north-west.

Craftsmanship and Elegance

Derbyshire's gentlemen needed prestige products to embellish their much-improved houses, and they were frequently in the town to sit on the bench, to conduct business, to attend the races and enjoy themselves at balls. Hence, by the early eighteenth century there were races on Sinfin Moor and in 1713 an Assembly Room was built in Full Street. To encourage the races, the Duke of Devonshire (as High Steward of the borough) in 1827 presented a massive gold cup. To make best use of such visits, the more opulent of the gentry required houses in Derby (by definition, town houses) and some fine buildings sprang up with this in mind, and their embellishment led to the creation of a group of elite craftsmen who could provide fine stucco ceilings, carved timber, moulded masonry and ornamental ironwork, not to mention portable goods, like fine fabrics, silver and ceramics.

Derby Race gold cup, as presented by the 6th Duke of Devonshire, 1827, made by Paul Storr. (Christies)

The doyen of these craftsmen was undoubtedly Robert Bakewell (1682–1752), England's finest native-born smith of wrought iron. He came to Derby after a glittering debut working at Melbourne Hall in 1711 and his work can be seen all over England, apart from Derby and the more local area. Furthermore, the tradition he started continued under his successors, Benjamin and William Yates, and was revived in the mid-nineteenth century by William Haslam and his son Edwin.

To get a flavour of Bakewell's work in Derby, visit the cathedral. He originally made the screen, the gates and railings outside, the mayor's pew, the communion rail, a portable altar and the railings protecting the monument of Thomas Chambers, who built Exeter House. The external ironwork was swept away in 1873, but the rest remains, although the screen has been extended (by Edwin Haslam) and provided with two extra gates, from work done by Bakewell elsewhere. The present exterior gates came from one of Derby's grandest (but also demolished) Georgian town houses that stood in St Mary's Gate.

The fine baroque plasterwork in the cathedral is by Joshua Needham, a Derby-born craftsman who worked extensively under Francis Smith of Warwick, the contractor for the job. His contemporaries were Abraham Denstone and Isaac Mansfield, both active nationally as well as in Derby, and Isaac's father Samuel executed the plasterwork at Sudbury Hall nearby and was probably responsible for the splendid ceiling of Newcastle House (see chapter 5).

Bakewell had made railings for Alderman Franceys's house in Market Head (see chapter 5) and this house also sported a rather fine frescoed ceiling in its first-floor saloon, depicting the gods on Parnassus. This was painted by Francis Bassano (1675–1746), a member of an Italian family of musicians who had come to London to join Henry VIII's band. With Puritans in control from 1642, they fled to Lichfield and came to Derby as lawyers at the Restoration. Francis, a younger son, took to painting. Although the ceiling was unforgivably destroyed in 1936, one can still enjoy his work on the roundel set into Bakewell's mayor's pew in the cathedral and four of the funeral hatchments (on the tower stairs and in the chancel) there too.

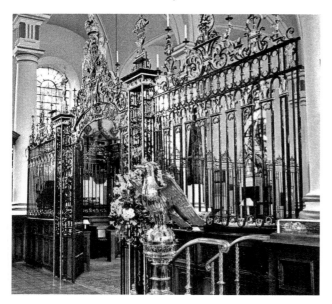

Derby Cathedral, view east showing the central section with overthrow and royal arms, of Robert Bakewell's incomparable wrought-iron screen of 1725. (Photographed 14 September 2015.)

Derby Cathedral, the painted roundel set in Bakewell's mayor's pew cresting, showing the borough of Derby's buck-in-the-park badge painted *c.* 1725 by Francis Bassano, photographed 14 September 2015.

The sort of houses for which all these trades created things suffered terrible attrition over the course of the twentieth century, but some examples survive and are worth visiting. In the previous chapter, the elegant Thomas Alsop's house (the Wardwick Tavern) and Alderman Franceys's house were mentioned, although it is difficult to visit the latter and the portions converted as shops are devoid of features. Also difficult of access, but surviving, are No. 11 Bridge Gate (of 1731, now part of the Convent of Mercy) with a fine staircase and panelled rooms, No. 36 St Mary's Gate (of 1736, currently being converted into three separate dwellings), which has a fine panelled saloon and elegant staircase, No. 3 St Mary's Gate (1729, under conversion), No. 27 Iron Gate (Queen Anne, interior regrettably stripped) and St Michael's House, Queen Street (*c.* 1675, interior also largely stripped). Because none are open to the public, they constitute a secret store of excellence.

St Mary's Gate, No. 3, designed as a grand residence by William Trimmer and built in 1732, most recently a solicitor's office. (Photographed 2001.)

DID YOU KNOW...?

The gods on Parnassus on Alderman Franceys's famous ceiling included portraits of Mr and Mrs Franceys as well. They survived the loss of the ceiling and are preserved at Derby Museum.

Fortunately, the Friary in Friar Gate (*see* chapter 4) does survive and has been converted into an entertainment venue which at least makes a visit possible. Built for banker Samuel Crompton by Richard Jackson of Armitage (Staffordshire) in 1730 and extended thirty-five years later, it has a fine timber staircase and panelling (much reused), although the rooms were opened out to give more space between the wars.

The First Factory in England

It was this desire on the part of the gentry and leading aldermen for the good things in life that drove attempt to start a silk mill in Derby from 1702. At first these failed, but in 1718 Sir Thomas and John Lombe from Norwich founded a new mill by the river, the year Thomas had obtained patent No. 422 for

> a new invention of three sorts of engines never before made or used in Great Britaine, one to wind...silk, another to spin and the other to twist the finest Italian raw silk into organzine in great perfection, which was never before done in this country.

The new mill was created by Derby engineer George Sorocold using the machinery perfected long before in northern Italy and pirated out of Piedmont by the adventurous John. It was also Britain's first factory – called by Lombe 'the Italian Works' – in which all the processes of manufacture were brought together under one roof using a common source of power.

The common source of power was the huge waterwheel, under which Sorocold is alleged to have fallen in a fit of arm-waving enthusiasm while demonstrating it to some visitors. It was replaced, probably when the mill was entirely rebuilt after a fire in the 1820s, by a smaller, more efficient iron wheel which survived to be photographed by

DID YOU KNOW...?

John Lombe was assassinated by an Italian employee on 16 November 1722 in revenge for his having stolen the silk manufacturing secrets from Italy. Lombe was buried on an island in the Derwent opposite his mill in a tall mausoleum set in an avenue of topiaried yews, but which was all washed away in a flood fifty years later.

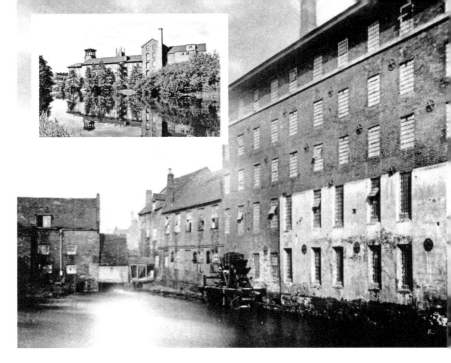

The Derby silk mill, captured by pioneer photographer Richard Keene, May 1855, showing the building as it was between 1823 and 1910 and the later (smaller) waterwheel. (DMT)

Inset: The Derby silk mill today, photographed in 1989.

Richard Keene in May 1855. The mill acquired a hipped roof and broached bell tower, the latter surviving a second more serious fire in 1910 when the building was effectively replaced by a three-storey building.

The building, part of Derby Museums Trust, is worth visiting, although opening hours continue to be restrictive until it fully reopens as a museum in 2018/19. Yet the magnificent gates that Robert Bakewell made for the site are still to be seen and if one were to amble between the building and the Derwent, one can see the arched undercroft upon which the original building stood when first built to designs by George Sorocold's friend, Henry Huss, who also designed the surviving seventeenth-century part of St Werburgh's church with its delicious carved reredos.

Other Luxury Industries

Although silk making continued in Derby until the 1860s, the manufacture of ceramics has fared much better. Again, the requirement of the prosperous local gentry for prestige goods led to the founding of a new industry. Somewhere around 1750, a French refugee called André Planché arrived and hired a pipe kiln to make small porcelain animals. Soon he had linked up with Staffordshire entrepreneur William Duesbury and not long afterwards they had founded a china factory on Nottingham Road, where they made china so expensive that Dr Johnson, when he visited in 1777, was reported to have remarked sourly that '... for that [price] he could have vessels of silver, of the same size as what were here made of porcelain'. Almost simultaneously, also *c.* 1750, a pottery near Cockpit Hill was founded by a man called William Butts (with two local bigwigs as backers) to make tableware.

While the Cockpit Hill potworks failed to survive a bank failure in 1779, the main works flourished mightily until 1848 when a handful of redundant workers revived the name and style at a factory in King Street, as we saw when we visited the Seven Stars Inn.

The demand by this time had extended well beyond the connoisseurs among the local gentry and had become international, which inspired the creation of a second porcelain factory in a redundant workhouse on Osmaston Road in 1878. This factory, which backs on to the Arboretum (*see* chapter 9) became the Royal Crown Derby china factory and in 1935 bought out and closed the ailing King Street works, ensuring continuity in the manufacture of luxury goods from 1750 until the present.

Both the Royal Crown Derby factory and Derby Museum have magnificent displays of Derby china, entirely complimentary – a visit to both is an imperative for the visitor. A long-term aspiration is to amalgamate the two museums on a single spectacular site.

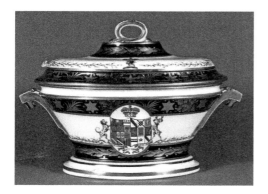 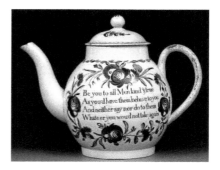

Left: Derby China: the Tamworth tureen, made in 1800 for locally based Lt Robert Shirley, Viscount Tamworth (son of 7th Earl Ferrers, whom he predeceased) whose arms, impaling those of his wife, Hon. Sophia Curzon, daughter of 2nd Lord Scarsdale, appear on the sides. (Bamfords Ltd)

Right: Derby, Cockpit Hill pottery. A creamware teapot of *c.* 1775. The firm went into receivership in 1779. (Bamfords Ltd)

Another luxury trade that began to manifest itself in the second quarter of the nineteenth century was spar turning. Not only are the fluor spars of the Peak District eminently suitable for the manufacture of luxury ornaments, but so was the polished black marble mined near Ashford-in-the-Water and the rusty veined cream alabaster from the Trent Valley.

The latter had been worked for noblemen's tombs and religious ornaments since medieval times, but one Richard Brown, who had family connections to franchisees working fluor spar and black marble, took over a redundant part of the silk mill and began carving funerary monuments as well as other decorative items such as chimney pieces and urns. As both he and his like-named son were also parish clerk of All Saints' (now the cathedral), their endeavours were able to flourish mightily. The younger (and exceptionally talented) Brown indeed shared a showroom in London with William Duesbury for many years. Clearly their products were deemed as complimentary.

There were also still skilled pewter and silversmiths in the town to add to the choice of luxury goods available. These were joined by a drastic improvement in the quality of local clockmaking driven by the need for precision machinery in the silk mill. What finally raised the quality of clockmaking however was the coming to Derby of John Whitehurst

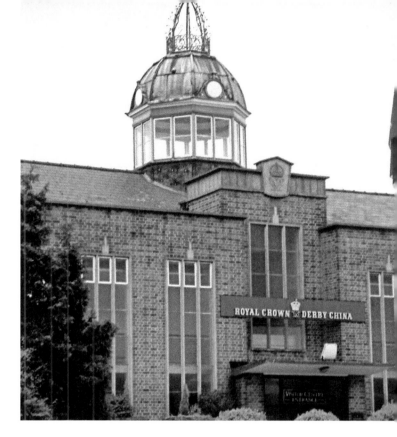

Osmaston Road, Royal Crown Derby factory, the rebuilt 1950s' frontispiece, photographed in 1988. The pioneering aluminium-framed dome dates back to 1878.

in 1736. The twenty-three-year-old son of a clockmaker at Congleton, he was a mechanical genius whose influence rapidly spread from the town to the country at large and finally around the continent. He made a turret clock for the Guildhall, then five years old, and this got him his freedom to trade. He quickly made a success of his trade, standardising on parts, economising on gadgets and ensuring all parts were cut from the same piece of metal to ensure uniform expansion and contraction. Thus he reduced prices and drove up quality.

He brought in one of his brothers to run his works and other family members, too. No one entering the clock trade after Whitehurst's first decade (during which he replaced the cathedral clock and carillon) could ignore this change and Derby clockmaking began to be recognised for its quality.

By the time Bonnie Prince Charlie had headed back north of the border, Derby had become an extremely opulent and recognised centre for luxury trades. This was to provide an unbeatable springboard for the next phase of the borough's development.

DID YOU KNOW...?

In 1787 Whitehurst invented a decimal-based system on universal measurement using a unit of 39.2 inches. He died before he could lobby for its adoption, but revolutionary France adopted a similar system – the metric system based on a unit of 39.35 inches just twelve years later and spread it by conquest.

7. The Secrets of Intellect and Industry

It is possible to argue that Derby's greatest contribution to the common good was neither steam locomotives nor Rolls-Royce cars, nor even aero engines, but was largely scientific and intellectual. A whole stream of men of extraordinary talent flourished in Derby between the 1660s and the beginning of the nineteenth century. It was extraordinary, diverse and entirely beneficial beginning with the first astronomer royal, John Flamsteed, and ending with the death of Sir George Clarke Simpson.

The First Astronomer Royal

To call this outpouring a stream would be appropriate, for there is a secret watery thread through it all. John Flamsteed was, due to the strains and stresses of the Civil War, born in Denby, 9 miles to the north-east of Derby, but his father Stephen was a Derby merchant and the family returned soon after young John was born. Sometime later, perhaps around 1670, Stephen Flamsteed built a new, rather opulent, house on Queen Street, which was inherited by John on his father's death and retained by the family until the 1720s.

The debilitating onset of rheumatic fever held back John's schooling and under the influence of Immanuel Horton, the Duke of Norfolk's agent at South Wingfield Manor, he developed a taste for mathematics – especially algebra, in which Horton was a pioneer – followed by an interest in sundials (another enthusiasm of his mentor) and in astronomy.

Queen Street, John Flamsteed's family home, pictured in 1952. It was rebuilt as John Whitehurst's house and in 1797 Joseph Wright died there. From 1865 to 1998, John Smith & Sons, clockmakers, occupied the building, reduced as shown in 1924. It is seen here with proprietor Howard Smith's Rover parked outside. (Smith of Derby Ltd)

Greenwich Royal Observatory, Flamsteed House, in 2014, as designed by Wren and equipped by Thomas Tompion 1675–76. Here Britain's first Astronomer Royal mapped the stars and compiled his *Atlas Coelestis.*

He was also taught surveying, and the co-ordinates of his incomplete map of Derby of 1673 centered on the river and using St Mary's Bridge as a datum point still exist, unrealised.

As early as 1669, when he was twenty-two, he had constructed a 3-foot quadrant, modified Halton's Improved Sundial, published several sets of tables, made five barometers and written *Notes on Some Eclipses of the Fixed Stars by the Moon.* In 1670, an introduction to the Royal Society helped him win a place at Jesus College, Cambridge, where he took his degree and accepted ordination.

In 1675, Charles II appointed him to the new post of Astronomical Observer; Wren built him an observatory at Greenwich and the celebrated clockmaker Thomas Tompion filled it with instruments. He was the first man to map the Heavens, although his own unadulterated version of his map of the heavens, the *Atlas Coelestis,* was published posthumously in 1735, sixteen years after his death.

A Genius with Hydraulics

From his father Flamsteed inherited both lead and coal mines, and he took a close interest in these, employing George Sorocold to devise ways of getting water out of them. \Sorocold was of a Lancastrian family of minor gentlemen, settled in Derby as a millwright. He married the daughter of Alderman Franceys (*see* chapter 6) and hung the famous peal of ten bells in the tower of the cathedral and devised a carillon to play tunes upon them.

His genius with manipulating water led to his installing, in 1691–93, a water supply at Derby by using a self-invented screw to raise water from the Derwent to a tank on Queen Street, from which it ran by gravity to conduits and wells in various parts of the town,

including the Market Place. The movement of the water drove a device which bored out elm pipes to contain the supply and which also knapped flints, meaning that the entire arrangement paid for itself. He devised similar arrangements in eighteen other parts of the UK and used his watery talents to embellish gentlemen's parks with cascades and to un-water mines, having honed his skills with the son of the famous land reclaimer and lead mine drainer, Sir Cornelius Vermuyden. He also was a friend of Thomas Savery, with Newcomen a pioneer of the atmospheric engine, an expensive but valuable aid to draining mines.

We have already seen how he devised the Derby Silk Mill for the Lombes, aided by local architect Henry Huss and Thomas Steer, who had helped him in the development of the first dock at Liverpool and river improvements in London, Yorkshire and Cambridge. He also surveyed and developed the Derwent Navigation in which the river between Derby and the Trent was straightened and freed of obstacles to take barges of goods, completed in 1721. He was also a keen Jacobite and seems to have gone into exile after the 1715 rebellion and the fall of his then Scottish patron, 'Bobbing John' Erskine, 23rd and 6th Earl and 1st Duke of Mar.

Sorocold seems to have died only in 1738, when his franchise on the Derby waterworks was surrendered to the Corporation, so he overlapped by two years another man with exceptional skills in the manipulation of water, John Whitehurst.

An Ephemeral Spa

One aquatic venture Sorocold does not appear to have been concerned in was the establishment, in 1733, of a spa by Ashbourne physician Dr William Chauncey. He erected a gabled brick house as the accommodation. Contemporary accounts say that he decided to exploit a mineral spring or 'watering place' (known to the Abbey of Darley) long neglected, near the Odd Brook below the Burton Road. An account says that he,

> put down a basin into the spring of it, to come out fresh; he built a cover over the spring which discharges itself by a grate and keeps the place aways dry. About twenty yards below the spa he made a handsome cold bath and some rooms to it ... two dressing rooms and with a large room over the whole and pleasure walks ... at considerable expense.

Chauncey himself died in 1736 and his widow let the place to Samuel Greatorex in 1740, who ran it until at least 1759. It occurs still as a spa in a deed of 1764, again two years later, but by 1784 it appears to have fallen out of use and was a tenanted house. From 1800 William Boothby lived there, extending it in Regency style and enjoying the small park which contained a long canal-like lake that Chauncey had provided (Sorocold could have engineered it, fed from the Odd Brook, but there is no proof). In 1832 it was sold and converted into a pub, its grounds being built over – miraculously the pub survives, in its original (if rather altered) building and is well worth visiting. It even has a modest garden in which to sit. It is a secret gem if ever there was one: still a watering hole, but no longer a spa!

John Whitehurst and the Lunar Society

We have already encountered this most eminent of Enlightenment figures, when he came to Derby in 1736 as a clockmaker. He was successful enough to be able to pursue

other interests, almost bewilderingly diverse. Quite apart from clocks, he perfected the barometer, made compasses, waywisers, industrial timers, pyrometers and counters. He was keen to improve what he called 'domestic economy', improving stoves, inventing the back boiler, running hot-water systems and flushing toilets, co-operating with friends and acquaintances to install them in peoples' houses and improve them empirically.

He was also a keen meteorologist, amateur astronomer and geologist. Indeed it was in the field of geology he made his most significant contribution to science, publishing *An Inquiry into the Original State and Formation of the Earth* in 1778, greatly revised in 1786. We now know he greatly influenced Scottish geologist James Hutton, who is generally regarded as the father of geological science.

From 1759 he made a number of important acquaintances, starting with Matthew Boulton, the Birmingham entrepreneur, and swiftly adding that most fertile-minded physician, Dr Erasmus Darwin, then of Lichfield. He made movements for a number of spectacular clocks for which Boulton made ormolu cases. With Josiah Wedgwood, James Kier, James Watt and a few others, they formed an informal grouping latterly called the Lunar Society, meeting over a meal in each other's homes once a month to discuss ideas, inventions, progress and generally have fun.

Not only did they discuss exciting developments in all manner of fields, but they were prosperous enough to put their ideas into operation, thus rapidly contributing to the advance of science and fuelling the burgeoning Age of Enlightenment. They also became increasingly radical, espousing the cause of the American colonists (encouraged by their friend Benjamin Franklin) and becoming active as opponents of the slave trade, a cause taken up also in Derby by Revd Thomas Gisborne of St Helen's House, who acted as his old university friend William Wilberforce's propagandist.

Whitehurst developed the hydraulic ram, originally to aid the deployment of water in gentlemen's parks, mainly ones landscaped by his friend William Emes (a follower

The house in Iron Gate where Whitehurst lived from 1736 to 1764. It had a weathervane and speed gauge on the roof, which could be read on dials either side of the parlour chimney piece. This was lost when the glass gallery was added by pioneer photographer Richard Keene in 1862.

Ormolu cased 'Venus' clock made by Matthew Boulton *c.* 1772 with a revolving chapter ring and superb quality eight-day movement by John Whithurst. (Private collection)

The early eighteenth-century panelled dining room at the rear of No. 27 Queen Street, where John Whitehurst entertained some of the most original minds of the age. The great man's portrait by Joseph Wright hangs on the wall (right), as does one of his unique angle barometers (left). (Smith of Derby Ltd)

of 'Capability' Brown), a long-time resident at Mackworth, just west of Derby. He also developed a device to raise water up a cliff to drive an Irish flax mill, a system of circulating warm water for domestic use fed by a back boiler attached to a cooking range and a system of flushing toilets pioneered at Clumber Park in Nottinghamshire for the 2nd Duke of Newcastle. In these hydraulic innovations, Whitehurst can be seen as a true inheritor of the tradition of George Sorocold.

Whitehurst lived first at No. 24 Iron Gate (where there is a plaque to mark his residency), behind which his works can still be seen. In 1764 though, he moved to No. 27 Queen Street, the house built by Flamsteed's father. Today it looks forlorn; a building at risk, unlisted, albeit protected by a conservation area. It lost its front part completely when the road was widened in 1924, but that was the portion rebuilt for Whitehurst by the Derby architect Joseph Pickford, which is a shame, although the replacement facade by T. H. Thorpe is essentially jolly. Inside, the panelled dining room in which Whitehurst thrice entertained the American and many times his friends in the Lunar Circle survives – just.

An Architect and A Painter

The man who obliged his friend Whitehurst was Joseph Pickford (1734–82) a London-trained architect who had arrived in Derby in 1763 as contractor for building the new Assembly Rooms to designs by Washington Shirley, 5th Earl Ferrers. In the event, he built for most of the Lunar Society and many of their friends. His *chef d'oeuvre* was St Helen's House, King Street, of 1767 (*see* chapter 4), now immaculately restored as accountants' offices, thought to be the finest Palladian town house north of London.

He built his own house on the North side of Friar Gate (then Nuns' Green, developed under an Improvement Act of 1768), No. 41, now Pickford's House Museum, an unmissable port of call for anyone hoping to appreciate Derby. A plaque to his memory was erected there by the Derby Civic Society and the city council in 2014. Nearby, Nos 27 and 44 Friar Gate are also his work, as is No. 36 Corn Market, a former town house-turned-coaching inn with a central carriage arch. His surviving Derby work includes the somewhat altered Orangery at Markeaton Park of 1772.

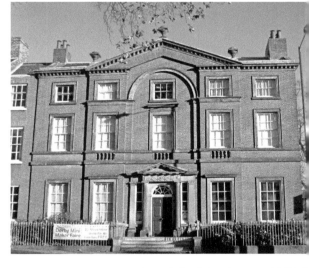

Friar Gate, Pickford's own house, now a delightful museum, photographed 19 November 2013. The house was in existence by 1765, and the facade was contrived to show off the architect's talents.

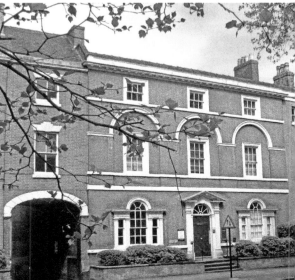

Friar Gate, No. 44 on 11 May 2015. A house designed in 1768 for William FitzHerbert of Tissington in the style of the house he built for the Beresford family at Ashbourne. It is now offices.

DID YOU KNOW...?

Although in the eighteenth century building was not permitted on Nuns' Green without an Act of Parliament, Joseph Pickford had built his house there by 1766 – two years before an Act was obtained.

In 1764 he also built a house – demolished in 1933 – in Strawberry Hill Gothick in Full Street, roughly where the statue of Bonnie Prince Charlie stands, for another person on the fringes of the Lunar Society, Peter Perez Burdett FRSA (1734–93), an astronomical protégé of Lord Ferrers and the man who surveyed only the second UK 1 inch: 1 mile county map (of Derbyshire) in 1767. Whitehurst made him a waywiser and a compass (the latter is in the Derby Museum), and he, abetted by Franklin, encouraged them all to join various metropolitan Freemasonic lodges.

Burdett, Pickford and Whitehurst were also all painted by Joseph Wright ARA (1734–97), who is, with Whitehurst, one of Derby's most celebrated sons. Derby Museum has the finest collection of his paintings available anywhere, the centrepiece of which is a work commissioned by Lord Ferrers called *A Philosopher Lecturing upon an Orrery*, which epitomises the thirst among the burgeoning professional class to drink deep from the well of fresh scientific discoveries then crowding thick and fast upon public consciousness. Here we see the very embodiment of the Midlands Enlightenment, and Wright's talent was employed after its completion in 1765 on further similarly iconic works: *An Experiment with a Bird in the Air Pump, An Academy by Lamplight* and *The Alchymist Discovering Phosphorous*. Like Pickford, who built for them, Wright painted not only members of the Lunar Society but important aspects of what they were doing, as epitomised in these important genre paintings and others, like those of the *Iron Forge,* the *Blacksmith's Shop* and *Arkwright's Mill* and so forth.

Ironically, Wright's last home, from 1793 until his death in 1797, was at No. 27 Queen Street, Whitehurst's old house, which he had vacated in 1780 when he moved to London. That this poor neglected building has been thrice refused listing by Historic England despite its concrete connections with the nationally important figures is astonishing, irrespective of the indignities which it has suffered over the years. Whitehurst's connection is all the more fascinating because, in 1864, John Smith & Sons, a clockmaking firm that still flourishes in Derby, moved to the building, only vacating it in 1998 – hence the turret clock protruding from the facade. More to the point, the first John Smith had been an apprentice and then an employee of the third John Whitehurst before setting up on his own.

When Whitehurst, encouraged by a sinecure at the Royal Mint obtained for him by his friend the 2nd Duke of Newcastle, finally left for London in 1780, his long-standing friend, the widowed Erasmus Darwin, was about to remarry. His bride was the widow of Colonel Edward Pole of Radburne Hall nearby. Darwin moved there, but hated the country and in

Classic Enlightenment
Joseph Wright: *The Alchymist
Discovering Phosphorous* of 1771
(and reworked in 1795). Many
of Wright's set pieces strongly
conveyed, as here, peoples'
fascination with science. This
piece is now in Derby Museum &
Art Gallery. (DMT)

Large (8-inch dial) cased compass made by
John Whitehurst for his fried Peter Burdett
to aid him in his survey of Derbyshire in
1763–66, and now in Derby Museum. He
made him a waywiser also, currently in
private hands.

1783 they settled in a large house in Full Street, where they reared a second family. Thus, having lost one Lunar Society luminary, Derby promptly gained another.

The Good Doctor

Dr Darwin had one of the most fertile minds of his era, outstripping that of even his friend Whitehurst. His commonplace books are packed with innovations and ideas which, like Whitehurst's, were ahead of their time. He was also a great naturalist, sharing his friend's enthusiasm for geology while translating Linnaeus and writing numerous works exploring nature and natural phenomena, fluently expressed in heroic couplets. To improve the water supply to his new house, he constructed the first artesian well, an internationally important device echoing Whitehurst's development of the hydraulic ram. These two devices have helped deserts bloom and rocky places thrive worldwide.

Erasmus Darwin's monocular microscope, which he used in his botanical studies as well as his medical practice and which is now in Derby Museum. Regrettably, his Derby house, along with Burdett's, was demolished in 1933. His house in Lichfield however is now an excellent museum.

DID YOU KNOW...?

Although Erasmus Darwin died in his chair at Breadsall Priory in 1802, the plaque to his memory on Exeter Bridge informs us he died in 1809. At Breadall, the memorial to Darwin's favourite horse, Doctor, informs us that the faithful animal passed away in 1809 – someone goofed!

Darwin refounded a philosophical society at Derby in the hope of replicating the fertility and renown of the Lunar Society. His theorising in natural history also laid the ground for the work of his grandson, Charles, in identifying the pattern underlying natural selection and also in recognising that it was the strongest and fittest who survived.

An Eminent Philospher

The great champion of these ideas, expanded and underpinned by observation by Erasmus Darwin's grandson, Charles, was Herbert Spencer (1820–1903). Spencer's grandfather had founded a school in Green Lane, teaching a science-based curriculum as devised originally by Erasmus Darwin. It was attended by the offspring of numerous local families, as was a rival establishment in St Mary's Gate run by Thomas Swanwick.

As a youth, Spencer had endured the devastating 1841 flood, had worked out its cause (the Derwent, in flood, being backed up by the Trent) and devised a solution, to be achieved through sluices on the Markeaton Brook and a large adjustable barrage on the

Exeter Bridge was completed by C. Herbert Aslin CBE in 1932 and endowed with stone pylons at either end – each bears a bronze plaque to an eminent Derby resident. This is the one honouring Herbert Spencer, ironically near the spot where he nearly drowned as a child and was rescued by a future mayor of Derby, George Holme. (Photographed 2010.)

Derwent south of the town centre. He submitted it to the Corporation, who dismissed this twenty-one-year-old whippersnapper as an impertinent upstart. Ironically, when the flood recurred, in even more devastating form, on 22 May 1932, Spencer's scheme was in consequence installed in full by the borough council and has worked faultlessly ever since.

Spencer's philosophy embraced the formulation of sociology, ethics and aspects of psychology, all fresh and unfettered by the musings of others. He believed, influenced by Erasmus Darwin, in the unity of all science, and also followed his thinking on education. Furthermore, he believed in the desirability of a radical diminution of interference of government in peoples' lives, a belief now, sadly, in eclipse.

With his death in 1903, the Derby tradition of natural philosophy, which we can trace back to the young Flamsteed in the early 1670s, seems to have finally ground to a halt, although the pioneer of modern meteorology, Sir George Clarke Simpson (1878–1965), might perhaps be included. Son of a mayor of Derby, who sold umbrellas in East Street (where there is a plaque commemorating his son's life), Simpson was meteorologist to Capt. Scott's Antarctic expedition before going on to be Director of the British Meteorological Office in 1920 to 1938.

Nearly all these remarkably important contributors to British science and art can be traced via the blue plaques erected to them by Derby Civic Society and co-sponsored by the city council. Locating them all in the central area constitutes a tour which takes in all the most important parts of the historic borough.

8. Secrets of Change and Upheaval

The trouble with chartered towns like Derby is that by the eighteenth century they were effectively broke and unable to fund developments that might well be sorely needed. Corporate income derived only from tolls and markets, none of which yielded significant amounts of money. When big projects were needed, a public subscription had to be opened, which happened for the building of All Saints' Church (of which the aldermen and brethren of the council were patrons) in 1723, the building of the new Guildhall (to designs of Richard Jackson of Armitage) in 1731 and for the building of a new Assembly Rooms in 1763.

Improvement Commissions
The Corporation made up the difference by selling its landholdings, much increased when Queen Mary bestowed the property of the local monastic foundations on it in 1555. To make any significant changes, it was necessary to raise a rate, and that could not be done directly under the 1668 charter. Instead, an Act of Parliament had to be obtained, and the rate levied by trustees on the Corporation's behalf.

Because Derby was tightly hemmed in by landed estates, the empty land within the borough had to be freed up, and in 1768 the first Improvement Act was passed, allowing a strip of Nuns' Green on the north side of Friar Gate east of Bridge Street to be sold for housing. This area was only occupied by the county gaol of 1755 and the Corporation hunting sables. The elegant houses built as a result make Friar Gate one of the most elegant Georgian streets in the area. The money raised was used for repaving, street lighting and turning the Green into a viable open space.

Marble bust of William Strutt FRS by Sir Francis Chantrey, now in Derby Museum

The next vital improvement needed was the virtual replacement of St Mary's Bridge, then only wide enough to accommodate a cart. A second improvement act was obtained in 1788 to sell land in St Peter's parish to do this. The chairman of the trustees was the young William Strutt (1756–1830).

DID YOU KNOW...?

St Mary's Bridge bears a clear completion date. The question is, can you locate it?

The Uncrowned king of Derby

Eldest of the three sons of cotton-spinning pioneer Jedediah Strutt, William was a natural polymath, a man who was interested in almost everything, and intelligent and capable enough to take advantage of such talent. Neither was he slow in putting himself forward or claiming credit for a number of innovations, not all of which were initially his.

How, at thirty-two, he could have persuaded the city fathers to let him chair the commission, is unclear, but financial clout undoubtedly had something to do with it. He was the first Derby person to whom the expression 'super-rich' could be applied. Furthermore, he was a keen disciple of the fertile-minded Erasmus Darwin, and he had also acquired architectural skills, perhaps alongside his fellow amateur, the future serial mayor and alderman, Richard Leaper. Who it was who taught them however can only be speculated at, although Joseph Pickford seems the most likely candidate.

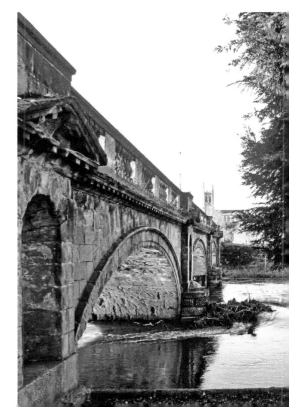

St Mary's Bridge, designed by Thomas Harrison of Chester and built 1788–94, seen here from the east bank (north side), February 2016, with Pugin's St Mary's in the distance. The bridge appears to be supporting more plant life than is good for it.

William designed at least five new bridges over the Markeaton Brook, which runs through the centre of the borough, and was quite prepared to design the major crossing of the Derwent at St Mary's, but in the end, wiser counsels prevailed and the job was given to Thomas Harrison of Chester. The resulting bridge is an exceptionally handsome example, still largely unchanged. The iron lamp supports on the south parapet are original.

Unfortunately, later culverting of the brook through the town led to the bridges losing their balustrading and being covered over, although Sadler Gate Bridge reappeared during improvement works in August 1967, and the cobbled top of St Peter's Bridge (complete with later tramlines) reappeared during pedestrianisation works in July 2004 (*see* Chapter 9).

But this was only a taster for Strutt. In 1791 he conceived of a third Improvement Act to carry on where the 1768 one had left off – and to keep going. The proposal was to sell off the rest of Nuns' Green, still then a large tract of common land between Agard Street and Kedleston Road, and invest the money in further street improvements, to include a whole complex of new streets west of Ford Street. A rate was to be levied and further improvements to infrastructure were promised.

The fact that Nuns' Green was bisected by the Markeaton Brook flowing west to east, meant that many of the people who had benefitted from the first Improvement Act (and occupied the grand Georgian houses built as a result) were horrified at the implications. With the brook available to power machinery, people envisaged an industrial quarter would quickly spring up and lower the tone of the neighbourhood enormously. They started a campaign of leaflets, anonymous letters, squibs and angry letters to the *Derby Mercury* and further afield. Strutt was on the defensive and recruited Lunar Society grandee Josiah Wedgwood to help put his case.

In the end, Strutt won, but the objectors' fears were realised in full, and more. Although further large Georgian houses were built along Friar Gate from Bridge Gate to Brick Street (both then new streets), the plots alongside the brook were indeed gradually acquired by entrepreneurs to build mills – for silk, narrow tapes, and various manufacturing functions. The irony was that the politically radical Strutt family built splendid workers' homes as a matter of course and it is doubtful whether he realised that not all those who followed his example

Sadler Gate Bridge, from the Strand, outside the 1964 extension to the museum, August 1967. The culvert in which the Markeaton Brook runs was undergoing major repairs, revealing the original bridge. (Courtesy of the late Roy Hughes)

DID YOU KNOW...?

The balusters of St Mary's Bridge were originally made of cast iron, but after a number were knocked into the river by a lorry in the 1970s, they were replaced, much more expensively, in carved stone.

Brook Walk, looking east from Bridge Street, 24 February 2016. Little Bridge Street joins from the left middle distance with the renewed iron footbridge running from its junction to Searle Street. The modern housing replaced early nineteenth-century mills in 2000.

Friar Gate, north side, part of the 1792 development, seen in 2008. The eight-bay house was designed by William Strutt for a member of his family.

would do likewise. As it turned out, the standard of housing swiftly went from dubious to scandalous, and by the 1840s, the entire area was a reeking slum called the West End.

Yet despite this misjudgement, Strutt continued to chair a sequence of improvement commissions, and with the clout that gave him, managed to improve the infrastructure of Derby very considerably, enabling the borough to make a smooth transition from eighteenth-century market town with small-scale manufacturing of essentially luxury items, to a Victorian industrial settlement.

Room for Expansion

Strutt was philanthropic enough to lead by example, too. In 1807 he acquired St Helen's House from anti-slavery pioneer Thomas Gisborne and proceeded to extend it to twice its original size. The 100-acre park, mainly lying to the north of the house, was blocking expansion in that direction. Therefore, in 1818, Strutt used the part of his garden between his house and the Derwent to lay out streets. Four were residential ones with houses ranging from Derby's finest Regency Terrace, North Parade, to rather mean artisans' cottages, all of which were demolished in the 1960s, but built by a new concept, the building club. One subscribed to the club and they used the capital to build, and subscribers were able to occupy the houses, paying a rent until the principal capital plus modest interest had been paid whereupon ownership devolved upon the occupier.

Numbers 1–16 North Parade consists of a pair of two-storey terraced ranges (but three on the east side, due to the fall of the ground), built on a generous scale and ashlar fronted, designed by architect William Smith. They were cleaned and the original railings replaced for the millennium and now look very impressive. Unfortunately, the building by the council of a residential tower block (happily, Derby's only one) behind in 1963 devalued the houses and increasing numbers are being converted to multiple occupation, a trend which could do with being reversed.

On Duke Street, Messrs Weatherhead, Glover & Co. built the Britannia Foundry, later celebrated as Andrew Handyside's, closed and demolished in the 1930s, but of which a reminder is the agreeable Foundry Inn, once adjacent. A vast silk mill beyond it on Bath Street was burned down in 2008 and replaced by ugly flats, despite the area being part of the Derwent Valley Mills World Heritage Site.

The foundry itself originally made ornamental works of cast iron for the embellishment of buildings and gardens, including the Arboretum (*see* chapter 9), very much in the Derby luxury trades tradition. After Handyside – a member of a Scottish engineering family involved in heavy industrial work in Russia – took over however, it specialised in railway infrastructure projects – bridges, station roofs and so on, not to mention pillar boxes.

North Parade, the two eight-house ashlar-fronted terraces built 1819–21 on the grounds of St Helen's House by architect William Smith, as restored in the 1990s, looking south-east in 2012.

Left: Bath Street mill, built in the 1850s by Alderman George Holme as a steam-powered silk mill, seen here in July 2009 after having been destroyed in a mysterious fire just after the grant of planning permission to convert them into ninety-three flats. All demolished in 2013.

Right: Andrew Handyside & Co. may have diversified into heavy industrial castings for railway building, but they still retained their catalogue of decorative and architectural cast iron, as exemplified by this large dolphin supported fountain sold in May 2009. (Mellors & Kirk)

Blue John

Another luxury trade that underwent a significant expansion during the period of the improvement commissions was that of Spar turning (*see* chapter 6). Derbyshire was rich in minerals and limestones which could take a polish and be carved and turned to make *objets de vertu* for the super-rich. The doyen of these was the unique and richly coloured purple/yellow fluor spar called Blue John from near Castleton (*see* chapter 7). Richard Brown the younger, a friend of Whitehurst, devised water-powered lathes and sawing machines, which increased quality and output and enabled him to move the works to St Helen's Street and install one of Matthew Boulton's steam engines, built under licence by a firm founded

Ashford black marble chimney piece designed by John Welch, made by Richard Brown and with an etched tablet by Henry Moore installed in the Judges' Lodgings, St Mary's Gate in 1809 and photographed before heavy-handed alterations relegated it to a ladies' powder room, 1993.

not long before by James Fox, a former protégé of Thomas Gisborne. The firm lasted until 1931, turning out things in black marble, Blue John, local Chellaston alabaster and also in imported marbles, including prestige chimney pieces and church monuments.

One of Strutt's great successes, having paved and lit the streets as a result of the 1791 act, was improving their security. Twenty watchmen had been employed for some years to patrol the streets to prevent disorder and crime. Strutt took a Whitehurst-inspired device called a noctuary, or watchman's clock, which was introduced into the streets in 1825, twenty-three (later reduced to nineteen) clocks being situated in boxes around the town and linked to a master in the police station in the Guildhall. Their use halved the number of men employed by the Watch from twenty to ten, and was warmly commended in 1833 in the first report of the Royal Commission on Municipal Corporations in England and Wales.

The commissions also oversaw the foundation of the Derbyshire General Infirmary (1806–10, architect W. Strutt), the building of the Derby Canal (1796), the building of the new county gaol on Vernon Street and the facilitating of the building of a Commissioners' church, St John's, at Bridge Street. A scheme to culvert the brook from Sadler Gate Bridge to the Derwent had to wait until later, despite it being one of the commission's aims.

Mechanism from a two-row watchman's clock made by John Whitehurst III in 1846. The levers depressed a pin when pressed by a passing watchman so that a supervisor could keep track of patrols. (Bamfords Ltd)

Left: Vernon Street: view due east from the front of the County Gaol, designed by Francis Goodwin and built in 1826, photographed 17 April 2012. It shows how, despite the prison at the end, the street was quickly built up with elegant stuccoed villas.

Right: Bridge Street, corner of Mill Street, St John the Baptist, 15 December 2015. Designed by Francis Goodwin, it featured pioneering use of cast iron.

Derby's First Twin Town

The biggest secret of all from this period however is Derby's first, and so far completely unacknowledged, twin town. In January 1783, Joseph Wright's elder brother John decided to accompany his life-long friend, Kirk Boott, the son of a market gardener who lived in Queen Street, to America to seek his fortune. They proceeded to London, where they appear to have enjoyed two months living the high life before Boott took a ship to Boston, unexpectedly leaving Wright behind. On arrival, he married the daughter of the captain of the ship on which he travelled. John Wright stayed behind because in those two months, socialising in London, he was offered a job in a bank, rising to a partnership in Messrs Smith, Wright & Gray, Lombard Street. He stayed in touch with Boott, and the latter named his eldest son John Wright Boott after him. Boott set up in Boston as an import-export agent and became extremely successful. Among the items Boott imported were pieces of Derby china (and Wedgwood), clocks, instruments and compass dials – products of Whitehurst's Derby works.

The second son, Kirk Boott (1790–1837), was educated in Ashbourne at the school founded by Erasmus Darwin's daughters, followed by Harvard. He later served in the British Army during the Napoleonic Wars, later living with William Strutt at St Helen's House while stationed in Sheffield. At Strutt's prompting, he made a tour of English textile mills in 1817–18, gaining much valuable expertise.

Later, he became the co-founder and prime mover of the city of Lowell, Massachusetts, founded as a centre of cotton spinning in 1822. This city he planned to call Derby but was overruled, it having bestowed upon it the name of Francis Cabot Lowell, one of his wealthier collaborators. He returned to Derby on a number of occasions, marrying Anne, daughter of Alderman Thomas Haden (Mayor of Derby in 1811 and 1819), a friend of Erasmus Darwin's who had been medical partner of Wright's other brother, Richard.

It will come as no surprise that Lunar Society member Richard Lovell Edgeworth, who had extensive American connections and property, kept William Strutt fully informed

of Boott's enterprise. How much of Strutt's own idealism and ingenuity went into the new settlement with its extensive mills it is impossible to say, but the Derby intellectual revolution of the eighteenth century was a fundamental inspiration at Lowell, and if it should prove to have been international in its consequences no one should be surprised.

It would certainly appear that the Bootts may have been in touch with the Duesburys too, for the unfortunate third William Duesbury sold his interest in the china works and went to Boston in 1815, settling in Lowell from its foundation. He worked for Boott as a chemist experimenting with fabric dyes (colour-making having been a lifelong interest), but having had three sons by his wife (whom he had married in Derby), he later bigamously married again, having two more sons and a daughter, before tragically doing away with himself on 12 December 1845.

Duesbury however was not the only pioneer settler in Lowell, although in the 1840s, when the workforce was vastly increased, most of the people were recruited from Ireland, then in the grip of the potato famine. One entrepreneur encouraged by Boott to settle at Lowell was the father of the painter James Abbott McNeil Whistler, who from 1832 made railway locomotives there. The son, once settled in England, later married into Alderman Haden's family. The links between Derby and Lowell are very extensive and admirably sum up the pioneering spirit of both emergent cities in the Regency period.

By breaking the constrictive band of landed estates around the edge of Derby, and using the improvement commissions to overhaul the infrastructure however, William Strutt laid solid foundations for Derby to move forward as a notable centre of industry.

Lowell, Massachusetts, Boott Mills, 2014. Kirk Boott junior designed the earliest Strutt-inspired mills in the town and ran it, unfettered by any democratic institutions, until his death in a road accident in 1837. Even the attached stair towers and one surviving octagonal lantern are closely reminiscent of that on the Derby silk mill. (Courtesy of the late John Kavanagh)

DID YOU KNOW...?

Kirk Boott, on his return from Derby with Anne, founded a new church for his city dedicated in his wife's honour – to St Anne. He told his friends that the architecture was an imitation of the Strutt's parish church in Derby, St Michael's.

9. The Secrets of Transformation

Despite the miseries of transformation from market town with a few luxury industries into an industrial one – the overcrowding and grinding poverty of the West End, the traumatic conviction for treason of the so-called Pentrich Revolutionaries in 1819, and the upheavals of the 1833–34 silk mill strike (initiated in Little Chester and only reluctantly joined by the workforce of the original silk mill) – Derby was changing fast.

The Coming of the Railways

A major catalyst was the coming together at Derby of three railway companies which opened in 1839–40: the Midland Counties Railway, which ran to Nottingham; the Birmingham and Derby Junction Railway; and the North Midland Railway to Leeds via Sheffield. They were persuaded by the Corporation, itself reformed to end the nepotistic chartered system of local government in 1835. The city fathers did not want three railway stations scattered around their much admired borough, least of all one on the edge of the Market Place. They brokered a deal and made land available south of the town centre, so that all three shared one station – the Trijunct Station, designed by Francis Thompson – so that their services could, in due time, continue on from one place to another rather than terminate in Derby. Then, in 1844, the so-called 'Railway King', the much maligned George Hudson of York, caused all three to amalgamate to form the Midland Railway (MR), to the lasting benefit of the town, henceforth one of England's most important transport hubs.

The new station was wantonly destroyed by the nationalised railway undertaking in 1984–85 and was substituted by a truly vapid replacement, but much remains to be seen and enjoyed. A fragment of the Trijunct station's lengthy facade survives at the south end of the site and forms an element in a conservation area including the Midland Hotel opposite, three streets of railwaymen's housing opposite the station and the Brunswick Inn, all built in 1841–42 to Thomson's design. The houses were saved at the eleventh hour by the Derby Civic Society and the Derbyshire Historic Buildings Trust, being exquisitely restored by the latter, and are well worth seeing.

The Midland Hotel, the oldest surviving purpose built railway hotel, has suffered some alterations and enlargements but still carries conviction as a post-Regency classical set piece and is well worth visiting, despite bearing the hallmark of an inept piece of recent rebranding having been gratuitously renamed the Hallmark. It bears a Civic Society blue plaque to locally born former manager Sir William Towle (1849–1929) who pioneered on-train railway catering. On Midland Road, its gardens play host to Sir Edwin Lutyens' magnificent Portland Stone war cenotaph memorial, and the Brunswick Inn is not to be missed either.

Opposite the latter are some later railway buildings which would buff up well, and Midland Road is embellished with further late Victorian ex-MR buildings by

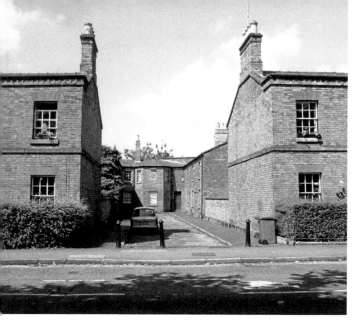

Left: Railway Terrace, Leeds Place, one of a number of secret (or at least sequestered) corners of Francis Thompson's 1842 triangle of varied workers' housing, as restored by the Derbyshire Historic Buildings Trust in 1985; their logo appears on the blind wall at the end. (Photograph taken 23 June 2014.)

Right: Francis Thompson Walk, off Midland Place, another quiet byway amid the railway cottages and named after the architect, 20 April 2016.

Charles Trubshaw (who also designed the rather over-scale Waterfall Inn, Midland Place, once the MR Institute). At the west end of that street, note the black-and-white-painted 1867 building which houses photographers W. W. Winter & Co., the earliest purpose-built photographic studio in the UK and still occupied by the company for which it was built.

The new railway company quickly realised that to manufacture its own equipment – locomotives, rolling stock, signalling equipment and the like – made sound economic sense, and quickly a works, which expanded at an astonishing rate well into the twentieth century, was established east of the station. The core of this went back to before the MR's foundation, including the first surviving railway roundhouse (a sixteen-sided affair by Thompson for the NMR, 1839–41), the firm's repair shop to its east and adjoining to the north, the MCR's locomotive shed, a delightful essay in functional neoclassical by William Parsons of Leicester. These have all miraculously survived and have been superbly restored by Derby College in 2009. It is possible to visit the Roundhouse by prior arrangement, although there are frequently public functions in it. To the west of the Roundhouse is the MR's original administrative offices with a classical locomotive entrance (complete with slot for tall chimneys) and an ashlar tower containing a Whitehurst clock.

The surviving railway works at Litchurch Lane, a fragment of the old carriage works, still makes excellent multiple-unit trains under the aegis of Messrs Bombardier (which they like to pronounce in a cod-French manner, the firm having originated in Quebec).

Entrance to the Roundhouse was via this grand pedimented aedicule with its vertical slot (now glazed) to allow the chimney stack to get past, 5 June 2011. The right-hand side of the later upper storey was damaged by fire in the twentieth century and replaced lower, spoiling the symmetry of the building.

Right: Exterior of the former NMR Roundhouse, pictured 5 June 2011 and as restored for Derby College.

Below: The Midland Counties Railway locomotive shed was less revolutionary than the Roundhouse but architecturally more accomplished with its fifteen-bay brick arcading, banding and gauged brick lintels, photographed 5 June 2011.

Further Expansion

These burgeoning works required that orders for numerous and varied minor components needed to be placed, and around the railway complex grew up a whole new quarter of the borough consisting of foundries, some really quite ambitious. These included a major brass foundry in Cotton Lane (Messrs John 'Brassy' Smith's), and many of these struck out independently as suppliers of railway equipment, both in the UK and abroad.

This whole southern portion of the borough soon became built up with hundreds of new streets of terraced houses (mainly built, as before, in short, separate runs), and punctuated by corner pubs, Nonconformist chapels and Gothic schools, most now closed or given over to alternative uses. The grandest church, built immediately south-west of the railway 'village', was St Andrew's, by Sir Gilbert Scott 1863–65, unfortunately closed and demolished in 1970.

The Arboretum

In 1840, this fast expanding quarter of Derby was given a valuable verdant open space through the philanthropy of William Strutt's youngest brother, Joseph. Fresh from co-founding the educationally beneficial Mechanics' Institute in The Wardwick (1836 and 1882, now a drinking establishment bearing the unlikely name of Revolución de Cuba) he gave 11 acres of land adjacent to a 'summer residence' he had built some decades earlier, and landscaped it using John Claudius Loudon as an arboretum, open to the public from 1840, at first for a modest charge except on Wednesdays and Sundays. It is the first public park in England, but was later taken over by the municipality, not necessarily to its advantage.

Derby's Arboretum in spring, showing the replaced Florentine Boar, 9 April 2011. The original, sculpted in Carara marble by William John Coffee, was destroyed by flying wreckage when a Second World War bomb hit the adjacent bandstand.

The Arboretum was embellished with over 1,000 trees grouped by type, interspersed with statuary from the founder's house in Derby, cast-iron urns from the Britannia Foundry, and ledges and pavilions designed in Jacobean taste by E. B. Lamb, who also rebuilt Strutt's villa, Rose Hill House, on the corner of Wilfred Street, for banker John Bingham. A grand eastern avenue lined with late Georgian brick houses leads from the Osmaston Road (called Little Moscow due to its coldness when the winter east winds blow), opening out into a square, the centrepiece of which is a pavilion-like entrance to the park by Henry Duesbury (of the china making family) topped by a larger than life-sized statue of Strutt by John Bell junior and flanked by a series of elegant white brick villas designed by Charles Humphreys in the 1860s, now regrettably subdivided as flats – to their detriment. An elegant post-Regency hotel on the Osmaston Road corner is now part of Royal Crown Derby's visitor centre. The factory itself was adapted from a workhouse originally built in 1836 and has a fine museum, complimentary to the Derby china displays at Derby Museum itself.

This park seeded other facilities for the inhabitants of the teeming streets that surrounded it. In 1904, a superb public baths (following on from some built fifty years earlier in Full Street) were built with a neo-Moorish interior and Jacobean/Arts and Crafts facade in Reginald Street on the south-east edge of the Arboretum, but was gutted in the 1980s and converted into flats. The streets adjacent are mainly lined by very ordinary palisaded terraced houses, but some are very superior, like the four grand terraces of eleven houses each, once within a gated enclosure which comprise Hartington Street, and others, less regimented, on Rose Hill Street on the south-west edge of the Arboretum. In

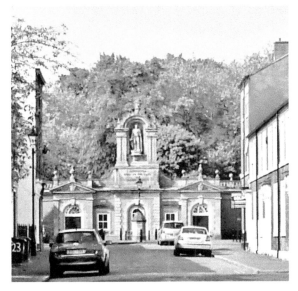

Left: Arboretum Square, seen from 'Little Moscow', showing Henry Duesbury's 1850 pavilion entrance and the statue of the benefactor Joseph Strutt (d. 1844) by John Bell, 12 June 2015.

Right: Reginald Street, the baths, designed by John Ward FSA and Alexander MacPherson, 3 April 2015. The ornate interiors were removed when the listed building was converted into flats in the 1980s.

Loudon Street, which ends on the western edge of the park, is a particularly fine Arts and Crafts house, now regrettably divided.

A Lost Village

The Arboretum and Hartington Street both form off-the-beaten-track but adjacent conservation areas and are well worth visiting, especially if combined with a call at the Royal Crown Derby visitor centre. The profusion of foundries and the constant noise of them and the onward march of housing swamped the ancient village of Osmaston, leaving only the hall and church. The noise and pollution eventually drove the tenants of the hall away in the 1880s and the owner, Sir George Wilmot-Horton Bt., sold it in 1888 to the Midland Railway as offices; before long there were railway lines right up to the main entrance and it was demolished as redundant in 1938.

Part of the park was sold to build a small enclave of railway housing between London Road and the canal, called Wilmorton after Sir George; the tiny and now vanished medieval church of St James beside the hall was also found inadequate for the spiritual needs of the population thereabouts. The problem of the church was addressed by the Currey family, long lawyers to the Dukes of Devonshire. Reverend Lancelot Currey, in 1905, built a magnificently proportioned brick church dedicated to St Osmund, designed by his talented brother, Percy, who added almshouses, a verger's house and a vicarage to make an almost collegiate quadrangle beside the canal and planted poplars to shield it from the adjacent industry.

This ensemble is now listed and in 1936–38, the London Midland and Scottish Railway erected their Railway School of Transport beside it, making another delightful and unexpected secret corner of Derby. The School of Transport, designed by LMS architect W. H. Hamlyn, is now a conference centre – a superb building with a central tower in Scandinavian classical style with exterior carving by Denis Dunlop. The beautifully restored interior, which may be visited, is still recognisably art deco, with a sweeping staircase leading off a hall with frescoes of transport history by Norman Wilkinson CBE (1878–1971), more famous for decorating the interiors of ocean liners of the period. The dining room is decorated by another mural, depicting the development of railway transport designed by Hamlyn and executed by his three assistants. There is a red Transport Trust plaque affixed to the exterior. It is open to visitors and has a good bar.

A visit to this much neglected enclave could be enlivened by a visit to the Navigation pub opposite St Osmund's and then a walk around 85-acre Alvaston Park and its science garden, situated on the other side of the canal bridge.

DID YOU KNOW...?

St Osmund's church dedication was inspired by the name of the Domesday Book tenant of Osmaston village nearby, Osmund, thought to have been a descendant of the Osmund from whom the place derived its name.

Nightingale Road, the Rolls-Royce office building of 1912 and later. The 1937 stone centrepiece (left) contains the ornate and recently restored Marble Hall, where foreign visitors were customarily received, 14 July 2016.

Wilmorton, the former LMS Railway School of Transport, now excellently converted as the Derby Conference Centre, seen in 2015. It was spot-listed to save it from demolition to make way for a housing estate in 2009.

Rolls-Royce

The boom in heavy industry in Derby continued into the twentieth century, culminating in the relocation, in 1907, of the three-year-old Manchester-based firm of Rolls-Royce, always referred to locally as 'Royce's'. This development, encouraged by a municipal promise of cheaper electricity, combined the two main threads of the development of Derby industry: it was firmly foundry-based and it made luxury products. Thus heavy industry was represented by the foundries needed to produce fine-quality engines for the firm cars, which were, thanks to their enduring reputation, luxury products *par excellence*, thus continuing the eighteenth-century Derby tradition of silk throwing, porcelain manufacture, architectural cast-iron founding and spar turning.

The firm's original works were largely destroyed after 2000, the company having moved out to the edge of the city where there is more room. But the grand frontage of the

DID YOU KNOW…?

Sir Henry Royce designed his office building with high sills so that the clerks could not stare idly out of the windows.

administrative block, designed by Sir Henry Royce himself and built in 1910–11, remains, enlivened by the impressive central stone-built marble hall, added in 1937, and a grand new entrance to impress visitors reopened after restoration in 2016. A Civic Society blue plaque to Sir Henry and Hon. Charles Rolls were added the following month.

The First World War spurred the firm to diversify into aero engine manufacture and the demands for these in the second conflict required the luxury arm of the firm to be moved out to Crewe, from whence car making never returned. After the war, Royce's became pre-eminent in the manufacture and development of aircraft engines, adding marine nuclear reactors and other products, endowing it with world status. A fine bronze statue of Sir Henry by Derwent Wood was erected in 1930 and is now in front of the firm's main offices in the suburb of Sinfin.

Changes Elsewhere

Anyone walking around the centre of Derby today will realise that great changes were made in the Victorian era and early twentieth century. When pioneer Derby photographer Richard Keene first recorded the streets from 1855, he preserved for us a vivid impression of a largely unaltered Georgian town, but even then changes were in progress, all of which he attempted to record.

Taking over from the Improvement Commissions, various privately funded consortia sought to continue development of the infrastructure. In 1837–39, the Brook was culverted between medieval St James' Bridge and St Peter's Bridge, creating Victoria Street, which was embellished by a noble Greek-revival building that provided accommodation for an Athenaeum Club and the Royal Hotel, the ashlar facade of which turned the corner into Cornmarket to adjoin the similarly styled Derby & Derbyshire Bank, all the work of architect Robert Wallace (see chapter 4). Thirty years later, the St James' Street corner was provided with a new classical stone-built post office, which complimented the ensemble well. This work was completed by an extension of the culvert from St Peter's Street to the Derwent, the resulting thoroughfare being called Albert Street. Later, the place where William Strutt had built his pioneering six-storey fireproof calico mill in 1793 was cleared in 1877 to create a space that connected to the grand south entrance to the Market Hall of 1864.

In 1866 Iron Gate was widened, followed by St Peter's Street in 1873, The Wardwick in 1882 (and 1913), and East Street (renamed from Bag Lane in the process). Queen Street had to wait until 1924 (involving the loss of the original facade of Whitehurst's House) and Full Street until 1943.

Nevertheless, the minor thoroughfares (described in chapters 1 and 2) largely survived, along with Thorntree Lane, itself an extraordinary survival which runs from beside the

A surviving medieval street: Thorntree Lane, which cuts across the later street pattern in the southern part of the city centre, 30 January 2014.

Left: Victoria Street, the former post office beside the culverted brook, by J. Williams, 1861. An ashlar-faced Italian palazzo, now an entertainment venue, 11 June 2013.

Right: Albert Street, 12 July 2012, south front of the Market Hall of 1864–66. The area in front is Osnbabrück Square, in honour of Derby's one surviving twin town.

DID YOU KNOW...?

Strutt's calico mill, despite being 'fireproof', was not only burnt out in 1852 but completely destroyed by fire in 1876.

HSBC (once the site of Joseph Strutt's home, Thorntree House) towards the Morledge, completely cutting across the street plan, strongly suggesting that it probably predates them. The eastern section is still cobbled.

Street Transport

These changes facilitated the introduction of street transport. An omnibus service had been introduced from the station (no need, surely, for the egregious Americanism 'Train Station') to the Royal Hotel in 1840, but it took another forty years to see the introduction of horse trams, the original depot for which, in Short Street off Friar Gate, still retains its tram tracks, but is currently blocked off while developers wrangle with the city council about future developments. The trams were electrified from 1904 and were phased out in favour of trolleybuses between 1930 and 1934, thirty-three years before the trolleybuses succumbed to motorisation. Now that neighbouring Nottingham has so successfully reintroduced trams, one wonders how sensible their abandonment in Derby really was; after all, it was a trend not repeated on the Continent. Steel must have been plentiful in 1934, for instead of ripping the tramlines up and scrapping them, they were left in situ and tarmacked over, as at St Peter's Bridge in Victoria Street.

A final introduction affecting the streets was the coming of a second railway to the borough in 1876, the Great Northern Railway branch from Ilkeston to Egginton Junction. Its four tracks sliced through Little Chester, crossed the Derwent, bisected Strutt's Park (in a cutting), crossed Friar Gate (on a fine bridge by Andrew Handyside & Co. with decorative cast spandrels) and onto an extensive built-up platform, upon which was built Friar Gate station, a locomotive shed, a vast bonded warehouse and an engine house, cutting off the burgeoning housing developments south of Friar Gate (an area called New Zealand) from the rather more refined suburb which grew up along Uttoxeter New Road from the 1820s. It closed to all traffic in 1967 and has lain criminally derelict ever since.

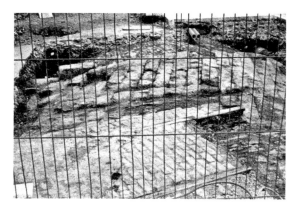

Left: St Peter's Bridge of 1795, designed by William Strutt, exposed along with the culvert brook below by roadworks, July 2004, with later tram tracks and cobbles still in situ.

Right: The wildly overgrown remains of the Great Northern Railway's former Derby (Friargate) station – a criminally wasted asset – seen on 12 May 2011. This view can no longer be taken due to further encroachment of nature.

10. Secrets of Modern Derby

Thanks to the impetus of street transport, Derby began to expand its boundaries and absorb otherwise small villages, which swiftly became suburbs, crowded with housing of all twentieth-century styles and sizes. Previously, the immediate edges of the borough had been host only to a handful of handsome Regency villas, effectively gentry town houses moved outside the built-up part of Derby to avoid noise pollution and the superfluity of people. These have, regrettably, been decimated. The best small one is Highfield House (1822), an ornament to the end of drearily 1960s Highfield Gardens; another good example is Nunsfield House (1826) in the suburb of Alvaston, on Boulton Lane, and in use within the community.

The Suburbs

Thus the borough expanded in 1902, 1928 and 1968 to its present boundaries, to enclose what today is a population of nearly 250,000. Most of the settlements had country houses, of which all but Littleover Old Hall (1896, now the County Fire HQ), Mickleover Manor (1849, now divided as dwellings) and James Wyatt's Allestree Hall (council owned and long derelict) have been sacrificed to philistinism and expediency. The associated parklands in many cases – Allestree (by John Webb), Markeaton, Darley (both by William Emes) and Chaddesden – have survived and flourished, although those at Osmaston and Spondon have been covered with, respectively, industry and municipal housing, as indeed has around two thirds of Chaddesden Park. Allestree Park is particularly spectacular despite hosting a golf course. Although Chellaston had no country mansion, it was absorbed in 1968 and has been built over.

Nevertheless, some secret and sequestered oases remain. Both Littleover and Mickleover have a sunken lane called The Hollow, and both are embellished with a certain

Boulton Lane, Boulton, Nunsfield House, designed by William Smith (of North Parade fame) for Charles Holbrook, 1826–28, faced in fine ashlar. After service as a library, it passed to the city council in 1996 and is now in community use. (Photographed in July 2006.)

Darley Park from the site of the demolished Darley Hall, 2015. William Emes made spectacular use of the fall of the land towards the Derwent (left). The course of the ancient trackway, which bisects the site of Derby, can just be seen running from mid-right to lower left as an *agger* ('bank') in the turf.

bosky charm and a timber-framed, sixteenth-century house in each, that in the former rather forlorn and the other well cared for. Indeed, were it not for the loss of the Regency vicarage for an ugly brick block of sheltered flats, the Square at Mickleover would be even more charming than it is. There is another surviving Regency villa, The Limes, still with a vestige of its small park down to Brierfield Way.

The centre of Allestree is still relatively intact, and a flavour of what used to be is still discernible at Chellaston and Chaddesden in the area around their churches. Indeed, Chaddesden church, built all in one campaign in the mid-fourteenth century (and tactfully restored by G. F. Bodley), is perhaps the finest of all the suburban parish churches. Despite the savage treatment of Spondon, the church with its tall spire and large Regency vicarage (now a care home) still make a fine ensemble and should be enjoyed with a pleasing group of Georgian cottages on Church Hill, the delightful and welcoming Malt Shovel Inn beyond on Potter Street and the impressive baroque homestead of 1741, still with some of its landscaped grounds not built upon.

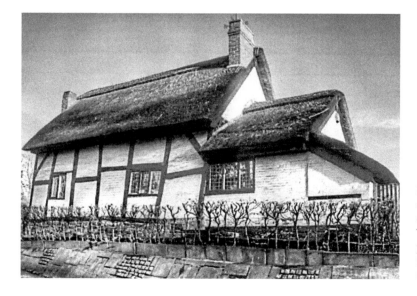

Littleover, the sixteenth-century cottage in The Hollow, photographed in 2014. (*Derbyshire Life*)

Left: Mickleover, The Limes, photographed from Brierfield Way in 2012. A huge Tesco store lurks within yards behind the house (built in the 1820s for the Wright family by amateur architect Richard Leaper), artfully screened by trees.

Right: Spondon, The Homestead, in 2013, one of Derby's few 'village houses' built in the provincial baroque style for the Antills, tanners (later related to Herbert Spencer), in 1741, with a Robert Bakewell balustrade leading to the entrance.

Below: Spondon, The Malt Shovel, an ancient and highly recommended pub, with fabric of the seventeenth and eighteenth centuries forming the eastern extremity of a delightfully unspoilt enclave centred on Church Hill, 14 July 2016.

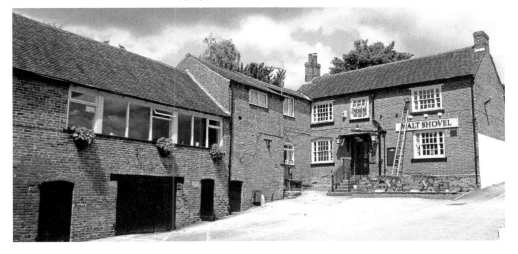

A Rival to Cromford

The real jewel is at Darley Abbey, to the north of the town centre, between the old A6 and the Derwent. It is without doubt the finest ensemble of mills in the entire UNESCO Derwent Valley Mills World Heritage Site (designated 2001). After the abbey itself was dissolved in 1539, the remains were secularised and the abbot's lodging became a seat. But no real village appeared, and until the 1860s it was all part of the Derby parish of St Alkmund, as was Little Chester, Little Eaton and Quarndon, the latter two still outside the city's boundaries.

The house was rebuilt for Alderman William Woolley, son of the county's first historian, by Francis Smith of Warwick while he was building Derby Cathedral in 1725. Having passed to Robert Holden, originally from a family at Aston-upon-Trent, it was again rebuilt by Joseph Pickford of Derby and the park landscaped by locally based William Emes in 1777–78. Everything changed in 1782 when part of the land was sold by the receiver in bankruptcy, banker Thomas Evans, to the one man willing to bail out the unfortunate bankrupt, none other than Thomas Evans!

He built, at the prompting of William Strutt, successively brother-in-law to two of his sons, a complex of cotton-spinning mills, powered by the Derwent, starting in 1782. The complex took nearly two decades to complete and remains the most perfect and intact of the Derwent Valley Mills. Around the turn of the eighteenth century, on the steep western bank of the Derwent, grew up a mill village which, despite the relentless infill of meretricious modern houses, is still one of the most complete Regency mill villages to survive in the UK.

Some of the mills can be visited (one is a wedding venue); the complex includes Darley's on the River, a restaurant of almost metropolitan standard, beside which is an original late eighteenth-century tollbooth from which, even today, the modest sum of £1 is collected from vehicles crossing the river at this point on the privately owned bridge.

In the 1790s, William Strutt designed Darley House for Thomas Evans (who lived to be ninety-one), but in the 1830s, the Evans family bought the hall. Both these grand houses have been demolished (hence the abundance of infill housing), in 1936 and 1962 respectively, although the stable block of the hall has recently been restored. Walter Evans commissioned Moses Wood of Nottingham to enlarge it for them, having previously employed him to build their church and the delightful classical school building on Brick Row.

There is much to see in the village, and after a walk around excellent refreshment may be had at the Abbey Inn, tactfully converted in 1979 using the one substantial conventual building surviving from before the Dissolution, previously converted as workers' cottages by the Evans family.

Darley Abbey, the mills (started in 1782), seen from the west (village) bank of the Derwent in 2013 with the toll bridge on the extreme left and Darley's on the river left of centre.

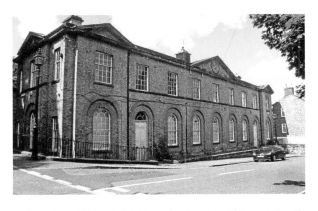 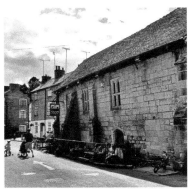

Left: Darley Abbey, Brick Row, the facade of Moses Wood's extremely refined school of 1824, seen 9 August 2014. The clock in the pediment is by John Whitehurst II and records internally on two dials in separate rooms as well.

Right: Darley Abbey, the Abbey Inn from Darley Street in August 2014. The early thirteenth-century building's original monastic function is not clearly understood; it was divided as cottages for millworkers in *c*. 1795. It was tactfully converted into a popular pub in 1979 – Darley Abbey's first, for the Evans family did not approve of their workforce drinking.

Transformational Secrets

Whereas the nineteenth century saw the widening of streets, the early twentieth century saw visions of far-reaching changes. A Central Improvement Plan was conceived in 1928 which envisaged dualising Full Street and Morledge and erecting a clutch of ambitious civic buildings around them. The appointment of a particularly gifted borough architect, C. H. Aslin, in 1929 led to major revisions, and work began in 1932. In the event, the coming of the Second World War stopped the scheme in its tracks, but not before much had been achieved, although still at a cost. To widen Full Street, the house of Erasmus Darwin was demolished, as was that designed in Strawberry Hill Gothick for the wayward genius Peter Burdett, both in 1933.

The one building left unfinished in 1939 was the Council House, started in 1937, dated 1941, but only completed (less a planned tower) in 1947, leaving many of the interiors rather plainer than had been intended. It was rebuilt in 2012 to increase accommodation, resulting in a vast glazed fissure in its monumental west (street front) and some interesting interior spaces, although the finish leaves much to be desired.

Some of Aslin's finished buildings have survived, including the impressive baths on Queen Street (added to by him to provide shops on Queen Street) and cleverly extended by Keith Hamilton in the 1980s. Aslin's Homelands Grammar School has gone, and his ingeniously designed parabolically planned bus station followed in 2007 to be replaced by part of a complex called Riverlights.

The best surviving Central Improvement Plan building today is the 1933 Magistrates' Courts (now the Local Studies Library and a restaurant), refurbished to a very high standard in 2014, and a showpiece for the exuberant use of metalwork that was Aslin's hallmark. It is well worth a visit.

Corporation Street, the Council House, 7 March 2016, showing the building as altered in 2012, with a huge glass insertion (right) and an extra storey in the roof.

Full Street, former Magistrates' Courts, 7 March 2016. Built in 1933, this listed building was refurbished to a high standard in 2014.

Also in 1927, the county was raised to a diocese by the Church of England, being carved off from that of Southwell, and the incomparable church of All Saints' was made the cathedral. Plans were put in hand to get Sebastian Comper to enlarge James Gibbs's fine town church. The secret is that a grandiose scheme was approved to provide a crossing under a baroque dome with two transepts extending to Amen Alley and across College Place (*see* chapter 2). Again, the money had not fully been raised when the war came, and under Provost Ron Beddoes, a much more restrained scheme from Sir Ninian Comper (Sebastian's son), in harmony with Gibbs' church was implemented. It opened in 1971 and was a complete success, and was really all the restricted site could cope with.

Post-War Perversity

Once the war was over, there was a prevailing atmosphere of elected members wanting everything new and brash, and the well-thought-out Central Improvement Plan was junked, and what is today called regeneration proceeded piecemeal. The museum was extended in 1964 thanks to the legacy of Alfred Goodey, mainly with the intention of housing his 500 paintings of Derby, some historic, some commissioned by himself from local artists beginning in the 1890s to record change and loss. They are at present only displayed temporarily and rotationally at the museum, but if they are on offer at any given moment it is worth going to see them.

The pre-war scheme to improve the town included the notion of tactfully extending the 1763 Assembly Rooms (by Lord Ferrers, Joseph Pickford and Robert Adam). By the 1960s, a scheme was put forward to replace them altogether, the opportunity arising after a minor fire in February 1963 caused damage to them. Today, Historic England would have insisted on repair (the damage was mainly cosmetic), but instead the council commissioned Sir Hugh Casson to design a vast new venue in concrete brutalist style. To build it, the entire north side of the Market Place had to be demolished (including the Duke of Newcastle's town house, forgotten behind its dowdy shopfronts).

The new building was opened to much acclamation in 1977, although its over-scale brooding presence did little for the medieval Market Place. The secret is that the previous, rather splendid and important, building did not vanish entirely. The surviving facade was banished to Crich Tramway Museum, where it can still be admired; the chandeliers are in the mayors' reception suite in the Council House and the two Rococo giltwood mirrors now decorate the saloon of Joseph Pickford's old house, since 1988 a fine branch museum.

The east side of The Morledge was renewed (to largely deleterious effect) from the 1980s until 2012; the west side was never properly redeveloped post war, and was virtually a derelict site until after 2000 when part was landscaped as a garden dedicated to the late Sir Peter Hilton, a much admired lord lieutenant. The part fronting the Market Place was infilled with a building of almost wilful ungainliness – an arts centre called Quad. The interior looks permanently unfinished, with much bare pipework and the coarse grain of coffering.

The Quad's architects took their cue not from the remaining Georgian two thirds of the Square, but from the doomed Assembly Rooms. Ironically, the latter will not be there much longer as a fire compromised them in March 2013, and after almost three years pusillanimity, the council decided to put the insurance payout towards a replacement, which will probably need to be even larger and hence even less appropriate for the site than its predecessor.

Market Place, Sir Hugh Casson's over-scale Assembly Rooms of 1972–77, empty and abandoned, 7 March 2016. Left: the First World War memorial by C. C. Thomson and A. G. Walker, 1924.

Left: Derby Assembly Rooms facade, by 5th Earl Ferrers and Joseph Pickford, 1763–64, as repositioned at Crich Tramway Museum, 1990.

Right: Market Place, The Quad, 17 February 2015. By Feilden, Clegg, Bradley (2005–08), the cross-legged piloti look barely up to supporting the superstructure of coloured glass.

Inappropriate development still plagues Derby. The plastic twelve-storey tower of Jury's Inn disastrously affects the setting of St Helen's House and challenges the refined pre-eminence of Pugin's St Mary's. Not content with which, a second (fortunately lower) but equally plastic hotel has been erected and opened in 2016 on Full Street, compromising the setting of the Grade I-listed cathedral, the silk mill and the art deco former Magistrates' Courts. Huge blocks of ugly student residences are also planned to wreck the setting of the Friar Gate Conservation Area and of Pickford's House, only metres away. While the establishment of the university in 1992 from the former HE College and Church of England teacher training institution was a considerable achievement, an accommodation crisis in the mid-1990s led to a desire to flood the most historic and fragile environment in Derby with cheaply built and over-scale buildings – a poor advertisement for a place of learning.

View from across St Mary's Bridge up Bridge Gate showing the bulk of the Jury's Inn and its effect on Pugin's St Mary's, 9 February 2016.

Derby Today

Derby's huge increase in heavy industry, which began in the 1840s, lasted for just over a century. The nationalisation of the railways led to the 'rationalisation' of equipment manufacturing, leaving Derby with only a limited element of what had once been a vast undertaking, but that happily continues to thrive, making multiple units under Messrs Bombadier (a Canadian firm), despite a few recent hiccoughs. Yet the diminution of railway equipment making led to a precipitous decline in Derby's foundries, and aggressive asset stripping accounted for most of them by the 1980s, leaving only Rolls-Royce and one or two quite modest outfits as suppliers of small components. Derby still retains a lively railway research sector, however.

A similar story affected one luxury industry – silk. A mid-nineteenth-century trade agreement with France killed the throwing of silk, and most manufacturers went on to diversify into silk goods, trimmings and elasticated products. The cotton industry, at the same time, transformed into a thriving narrow tapes-making hub. Nevertheless, neither of these managed to survive the economic vagaries of the last half of the twentieth century.

Ironically, it was the luxury industries that came through, despite the loss of spar turning in 1931 and the flight of Rolls-Royce in 1939. Fine china is still being made at the Royal Crown Derby Works on Osmaston Road (founded 1877 and incorporating the 1750 tradition of the original factory) and high-quality clocks are still being made at a works on Alfreton Road by (John) Smith of Derby Ltd, which, although only founded *c*. 1848, was brought into being by a former apprentice and assistant of John Whitehurst III, whose firm was founded in 1736, and to the goodwill and tradition of which the first John Smith succeeded.

Osmaston Road, Royal Crown Derby china factory, July 2005. The centrepiece as rebuilt in 1952 with original pioneering aluminium-framed dome.

Furthermore, the city of Derby managed to foster further diversification, attracting financial services, high-tech and information technology firms, most of which have prospered mightily and have raised the commercial standing of the city to new heights. One incentive was to develop Pride Park on the site of the former city dump on an initiative of Lord Heseltine when Environment Secretary. Although slow to pick up, is subsequent development was rapid, an additional filip coming from the decision of the late Lionel Pickering to relocate Derby County FC to Pride Park. In 2015, the stadium (now the Ipro Stadium) was joined by a velodrome, known locally as the Cow Pat, a supposedly multipurpose arena, but still beset with under-usage.

Such was the success of the area, not to mention spin off areas like the Meteor Centre and Wyvern Park (both retail), that a new area to accommodate this burgeoning sector on the edge of the suburb of Chellaston, Infinity Park, is now also developing fast, all this in the teeth of a local administration supinely wallowing a victim culture of 'cuts', bereft of imagination and gripped by self-inflicted inertia. That Derby is still so successful is a great tribute to its private sector and the determination of its citizens to get on.

Such rapid change has, of course, left Derby with a plethora of contrasting secret places and other, less tangible, secrets which this short account has attempted to highlight. Any newcomer or visitor may wander around some of the places mentioned and still, without doubt, be surprised at what they encounter.

Pride Park, Ipro Stadium, from the velodrome, 14 July 2016.